POSTCARD HISTORY SERIES

Fairfield and Southport

IN VINTAGE POSTCARDS

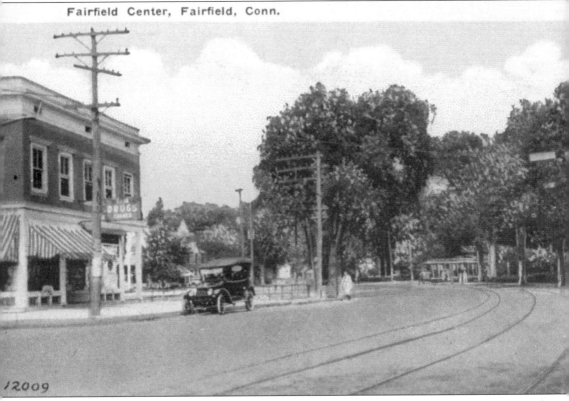

12009

This is a postcard of the Post Road at a time when trolley cars and automobiles shared the road. It was not until 1916 that Fairfield's streets were officially named and street signs were installed. In 1922, the local trolley fare had reached 10¢ and residents called for an immediate reduction.

POSTCARD HISTORY SERIES

Fairfield and Southport

IN VINTAGE POSTCARDS

Beth L. Love

ARCADIA

Published by Arcadia Publishing,
an imprint of Tempus Publishing, Inc.
2 Cumberland Street
Charleston, SC 29401

Printed in Great Britain.

Library of Congress Catalog Card Number: applied for.

For all general information contact Arcadia Publishing at:
Telephone 843-853-2070
Fax 843-853-0044
E-Mail sales@arcadiapublishing.com

For customer service and orders:
Toll-Free 1-888-313-2665

Visit us on the internet at http://www.arcadiapublishing.com

For Michael and Matthew, whose inquiring minds remind me of the importance of taking the time to be curious. To Hogan, did you ever think that one postcard from an antique show would turn into this?

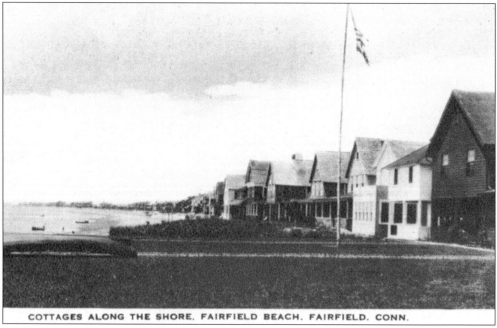

COTTAGES ALONG THE SHORE, FAIRFIELD BEACH, FAIRFIELD, CONN.

Many beach cottages along Fairfield's shore were destroyed by the hurricane that struck New England in September 1938.

CONTENTS

ACKNOWLEDGMENTS

Thank you to Ruth Bedford, Kassie Foss, Jeanne Harrison, William D. Lee Sr., and Ed Michaels for kindly allowing me to include their postcards in this book.

Thank you to Dan Caruso for making some important introductions.

A special thank you to William D. Lee Sr., Fairfield's former town historian, for being so generous with his time, for sharing so much of his personal collection with me, and for providing me with a true sense of Fairfield and its history.

INTRODUCTION

This book represents a portion of a collection that my husband, Hogan, and I began more than 12 years ago. Many of the postcards included in this book were displayed as part of Fairfield's 350 Years of History exhibit at the Burr Mansion in March 1989. The exhibit was one of many events held that year in celebration of Fairfield's 350th anniversary.

As our collection continued to grow, it was never our intention to write a book; rather, it was a never-ending quest to find "just one more card that we did not have." It was not until our son, Michael, took an interest in the postcards and started to ask questions (to which we did not have the answers) that the research began.

These postcards served as a means of simple and inexpensive communication, more sincere and endearing than any computer-generated icon stating, "You've got mail." They are unique treasures that offer glimpses of Fairfield's past. The messages that these postcards contain serve as a reminder of simpler times. The photographs preserve forever a Fairfield that many of us never knew. In their own way, they prove that there is more to Fairfield than the current issues being debated in the editorial pages of our local newspapers.

Today is Memorial Day, May 29, 2000, and I am reminded that every day is history in the making. No other event in town attracts as many people as the Memorial Day parade. The crowds stretch for miles. Our younger son Matthew, Hogan, and I eagerly await the arrival of Michael's Cub Scout pack float. We are sitting in front of the First Church Congregational—across from the reviewing stand—in almost the same spot I stood on October 26, 1984, to listen to then presidential candidate Ronald Reagan on a campaign stop in Fairfield. Today, like that drizzly, damp October day, I am taking it all in. There is excitement and the smell of pancakes from St. Paul's annual pancake breakfast. In the air, there are red, white, and blue festoons hanging from balconies, poppies and American flags, and people everywhere. This is Fairfield at its best: patriotic, proud, and united.

My objective in having this book published was to be able to share my family's extensive postcard collection of Fairfield and Southport while incorporating interesting facts and personal accounts that would appeal to almost any age group. I hope this book encourages readers to enjoy the many enduring traces of Fairfield's past. Everyone is always in such a hurry, but Fairfield and Southport really are beautiful places. Take the time to really look; what you see may offer a new perspective on the town so many call home.

One
TOWN HALL GREEN

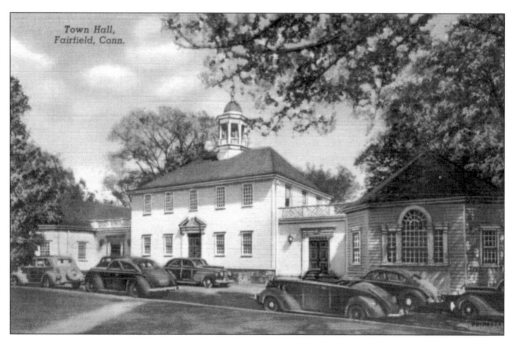

The Fairfield Town Hall and the Fairfield Town Hall Green have been familiar gathering places for generations. On October 26, 1984, a multitude of people assembled here to listen to then presidential candidate Ronald Reagan on a campaign stop in town.

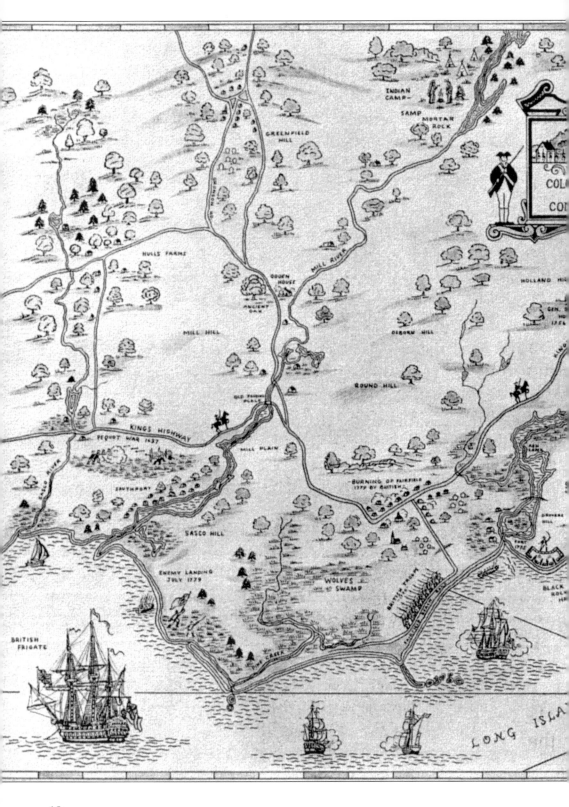

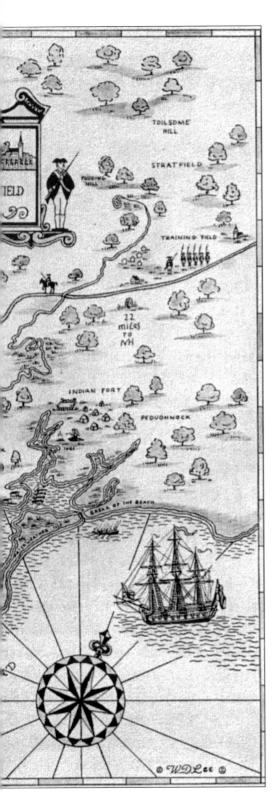

Fairfield was founded in 1639 by Roger Ludlowe when he and a group of settlers purchased land from the Native Americans. The land had been called Uncoway, meaning "looking forward; a valley." In the early 1640s, the name was changed from Uncoway to Fairfield. This is a map of colonial Fairfield as it appeared in 1779, the same year the British burned Fairfield. (Courtesy of William D. Lee.)

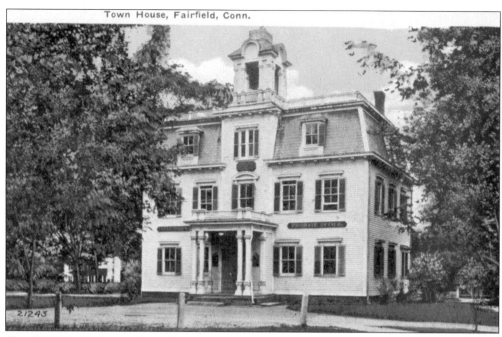

The old Fairfield Town Hall was known as the Town House until the late 1800s.

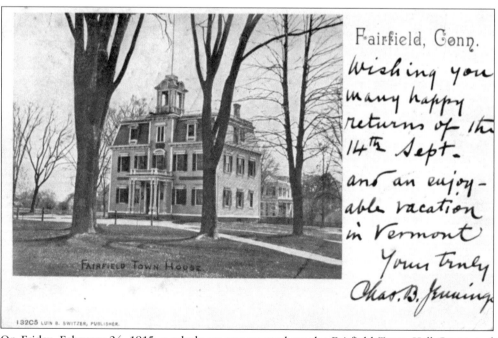

On Friday, February 24, 1815, a whole ox was roasted on the Fairfield Town Hall Green and about 6,000 people gathered to celebrate American peace with Great Britain after the War of 1812.

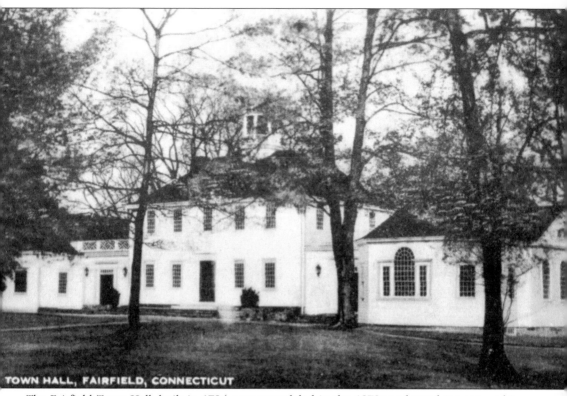

TOWN HALL, FAIRFIELD, CONNECTICUT

The Fairfield Town Hall, built in 1794, was remodeled in the 1870s and was later restored in 1936. The two wings on either side of the original building were added at that time to create additional office space.

Town Hall and Grove, Fairfield, Conn.

The boulder on the Fairfield Town Hall Green was brought from Osborn Hill in 1900 by Frederick Sturges. The Eunice Dennie Burr Chapter of the Daughters of the American Revolution (DAR) placed a tablet upon it to commemorate the settlement of Fairfield by Roger Ludlowe. The fir tree on the town hall green, which is decorated with lights every Christmas, was a gift from Annie B. Jennings. The town bulletin board, still located on the town hall green, was a whipping post during the early colonial years.

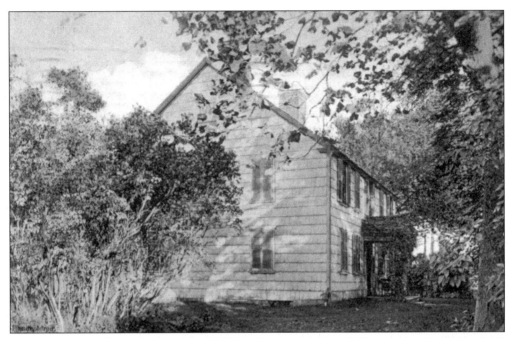

Benson Tavern is located where the Old Post Road meets South Benson Road and was built immediately after the Revolutionary War.

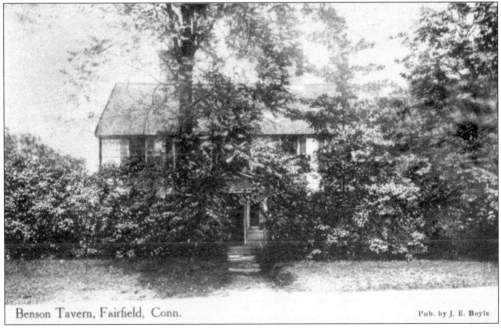

Benson Tavern, Fairfield, Conn. Pub. by J. E. Boyle

Originally occupied by Gen. Elijah Abel, who served as sheriff of the county, Capt. Abraham Benson later converted it into Benson Tavern. Since Benson Tavern was situated along the stagecoach route between New York and Boston, it was a popular resting spot for travelers. It was reported that Pres. Andrew Jackson once dined here.

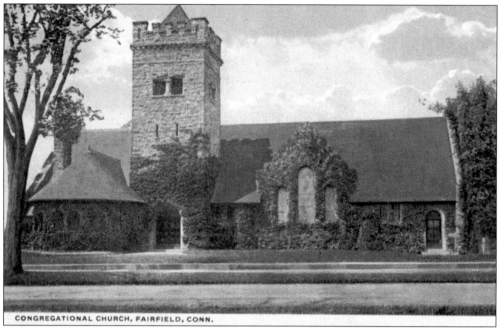

CONGREGATIONAL CHURCH, FAIRFIELD, CONN.

The First Church Congregational was organized and its first structure built on the present site in 1639. In addition to a church, it served as the town's meetinghouse.

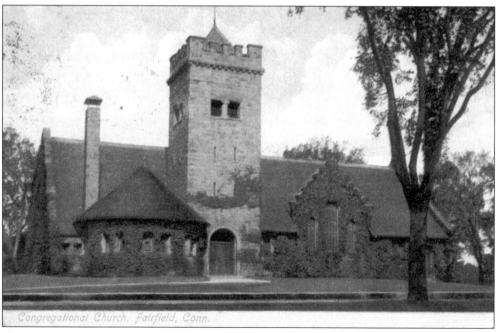

Congregational Church, Fairfield, Conn.

The First Church Congregational's current structure was built in 1891. The Memorial Tiffany Windows were presented by descendants of its early membership. Tours of the Tiffany windows are given every Memorial Day.

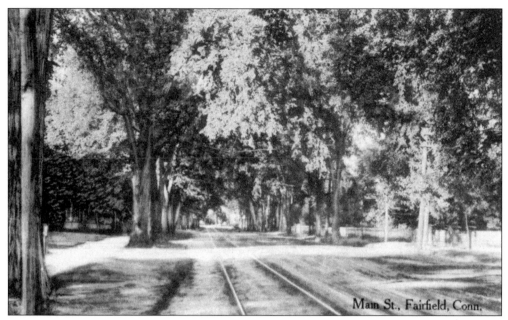

Although this postcard of a quiet, tree-lined Main Street, now known as Old Post Road, may make life in Fairfield seem uneventful, the message on the card dated June 10, 1912, has quite a different ring. John writes the following to Jack in the town of South Britain: "We're having a wonderful time and everything ideal. Better come down a day. Open house Tues. eve, dance Thur. eve. and big time Fri. night. About a dozen here yesterday and eight for the week. Good weather for autoing."

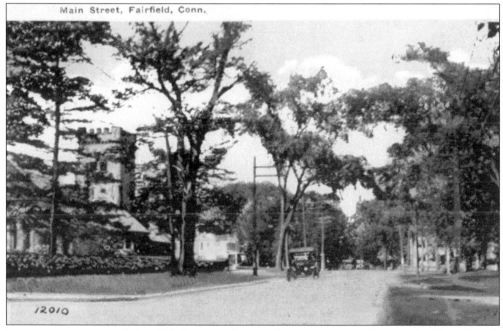

Here is a postcard of the Old Post Road, once known as Main Street. The First Church Congregational is on the left. St. Paul's and the Fairfield Town Green are on the right.

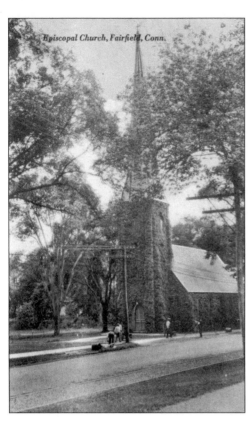

With Trinity, the mother parish, in Southport, the congregation wanted an Episcopal church in Fairfield and went on to found St. Paul's.

Consecrated on May 20, 1856, St. Paul's was built on a foundation intended for the county jail. (Courtesy of Ed Michaels.)

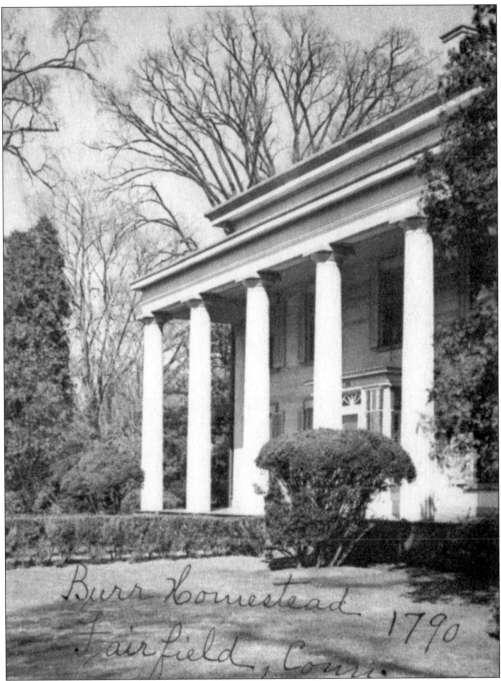

Burr Homestead
Fairfield, Conn.
1790

The Burr Homestead was built *c.* 1700 by Peter Burr. On August 28, 1775, it was the setting for the wedding reception of John Hancock, president of the Continental Congress, to Dorothy Quincy, daughter of patriot Edmund Quincy. The Burr Homestead was destroyed by fire on July 7, 1779, when Fairfield was attacked by British troops. The Burrs had a new house built on the same site, and construction was completed in 1793. Under the direction of John J. Sullivan, first selectman, the town purchased the Burr Homestead in 1962.

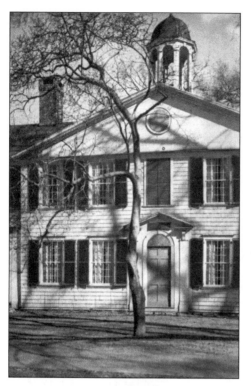

The Old Academy, built in 1804, was originally located on the Old Post Road between the Burr Homestead and the Fairfield Town Jail (now the location of St. Paul's). The academy was later moved to its current location on the Fairfield Town Hall Green. The building was renovated in 1927–1928 by the Fairfield Historical Society and the Eunice Dennie Burr Chapter of the Daughters of the American Revolution. It is now the permanent home for this chapter of the DAR.

In 1893, the Eunice Dennie Burr Chapter of the Daughters of the American Revolution began inviting the public to join in the observance of Independence Day on the Fairfield Town Hall Green. The ceremony began at 10:00 a.m. with a brief patriotic address and the singing of national hymns. The tradition continues to this day, with a tour of the Old Academy as part of the festivities.

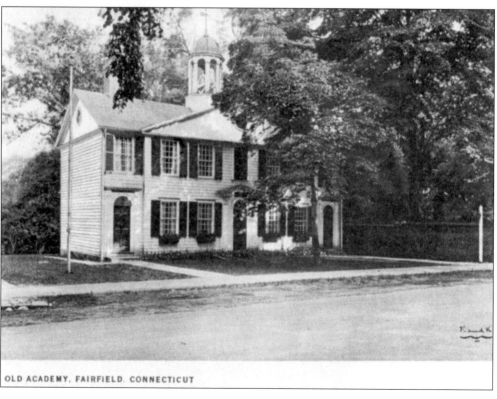

OLD ACADEMY, FAIRFIELD, CONNECTICUT

20

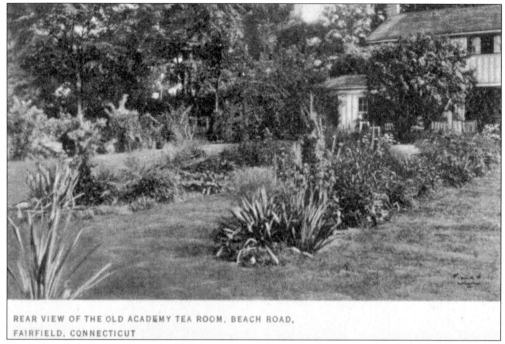

REAR VIEW OF THE OLD ACADEMY TEA ROOM, BEACH ROAD,
FAIRFIELD, CONNECTICUT

The Old Academy Tea Room was considered "a delightful spot in which to 'bide-a-wee' and rest." One would think that the Old Academy Tea Room and the Old Academy were one and the same building, but this is not the case. The Old Academy Tea Room building still exists today on Beach Road.

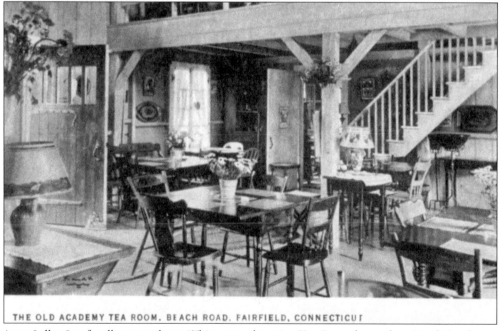

THE OLD ACADEMY TEA ROOM, BEACH ROAD, FAIRFIELD, CONNECTICUT

Anne Lalley Lee fondly remembers, "This was a charming Tea Room located on Beach Road near the Town Hall Green. I was delighted to celebrate my sixteenth birthday at a luncheon here with my friends, white gloves and all, on August 26, 1942."

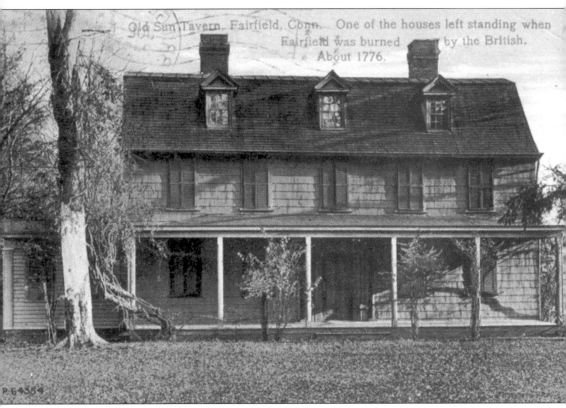

The Old Sun Tavern is located on the Fairfield Town Hall Green between the town hall and Independence Hall. Although this postcard indicates that this was one of the houses left standing when the British burned Fairfield in 1779, it was actually built in 1783 by Samuel Penfield and visited by George Washington in 1789. The Town of Fairfield purchased the building in 1978 and extensively restored and refurbished it.

Two
ALONG THE POST ROAD

This postcard shows a block in the heart of Fairfield's shopping district as it appeared for decades.

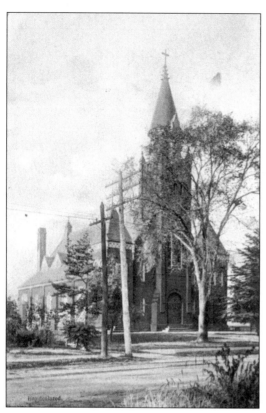

The original church of St. Thomas Aquinas was dedicated in 1854 and was destroyed by a fire of unknown origin in 1892. This postcard shows St. Thomas Aquinas Church as it appeared in 1894. The church was demolished in 1956 to make way for the current structure, which was dedicated in 1957.

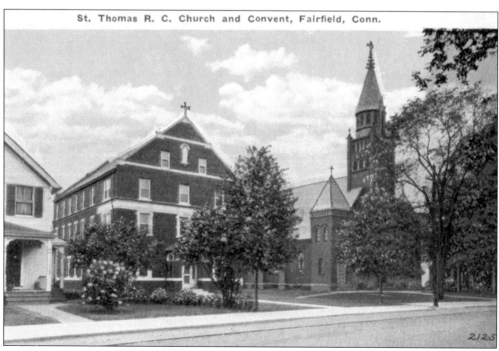

The convent was built in 1923 on land purchased by the St. Thomas parish almost 50 years earlier.

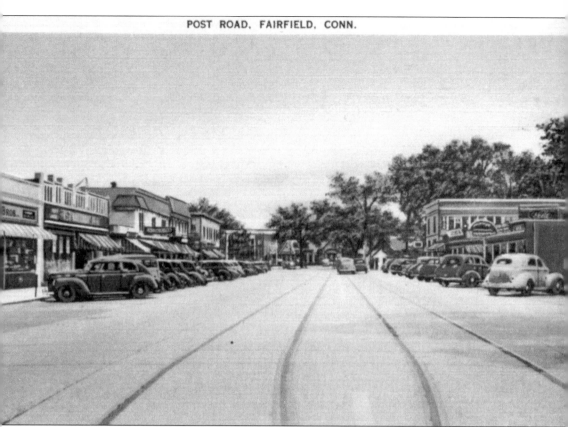

The trolley tracks are long gone and, with the exception of Memorial Day, no one parks on the Post Road like this anymore. The *Fairfield News* reported in January 1931 that traffic lights were planned for the Post Road.

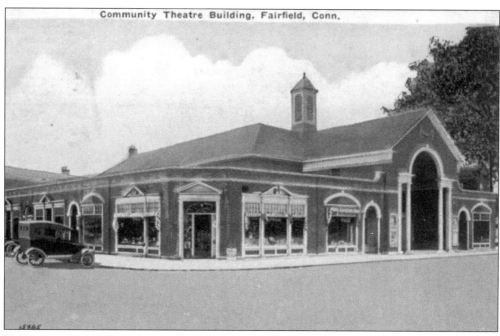

This postcard of the Community Theatre is postmarked 1925, approximately two years after the theater was built. A second floor, which is part of the building today, was added later.

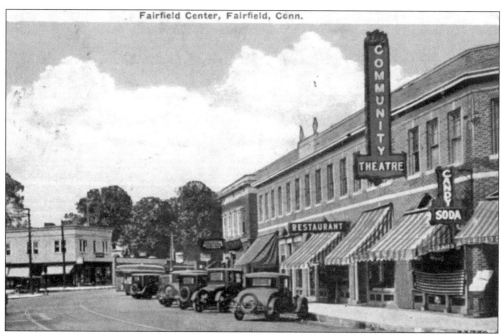

The demolition of the Fairfield Store building (white building on left) in the spring of 2000 was bittersweet. Its loss changed forever the downtown many residents grew up knowing; at the same time, that loss brought with it plans for revitalizing Fairfield's downtown area.

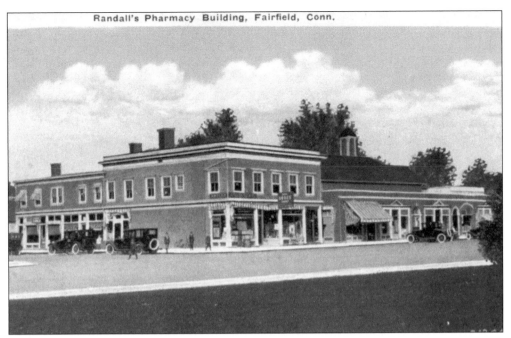

Randall's Pharmacy, which was located on the corner of the Post Road and Sanford Street, completed the Community Theatre block.

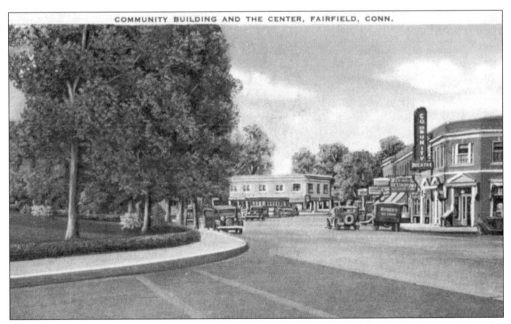

In 1923, combined commencement exercises for Pequot, Dwight, Grasmere, Lincoln, Washington, Holland Hill, and Sherman schools took place in the Community Theatre.

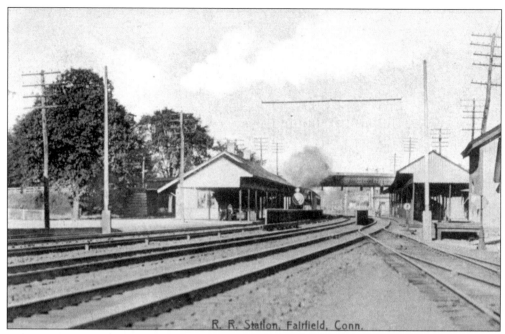

Rail travel began in Fairfield in 1848. By 1930, there was a decline in train travel due to the popularity of the automobile and the construction of new roads.

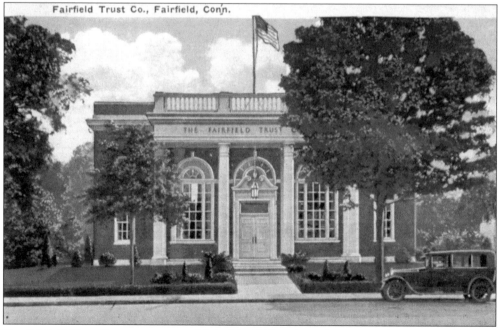

The Fairfield Trust Company was established in 1920 and was located on the corner of the Post Road and Old Post Road where Chase is now.

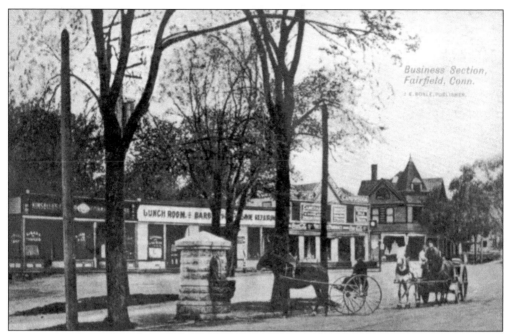

This postcard shows a block of Fairfield's business district as it appeared in 1909. This block was located on the Post Road between what is now Unquowa Road and Unquowa Place.

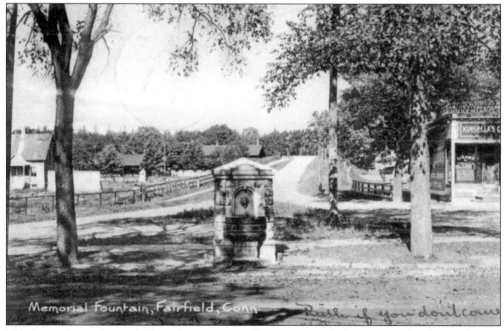

This fountain was located where Unquowa Road intersects with the Post Road and the Old Post Road. In this postcard, Unquowa Road runs up the hill at the rear of the fountain. Fleet Bank currently stands in the general area where Kinsella's was.

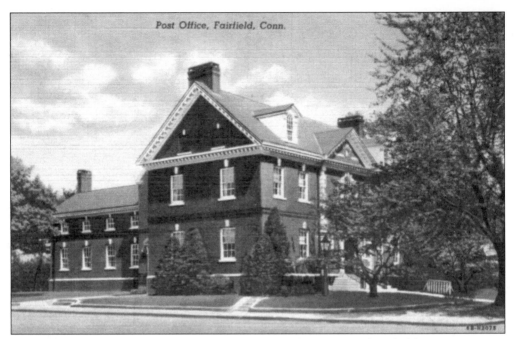

Post Office, Fairfield, Conn.

This is not the post office, but the Fairfield Memorial Library. It was founded by Morris Lyon in 1876 as a memorial of American national independence and other important events.

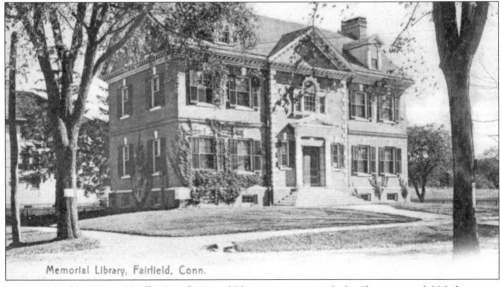

Memorial Library, Fairfield, Conn.

In 1879, the library could afford its first paid librarian, Anne Nichols. She was paid $25 that year.

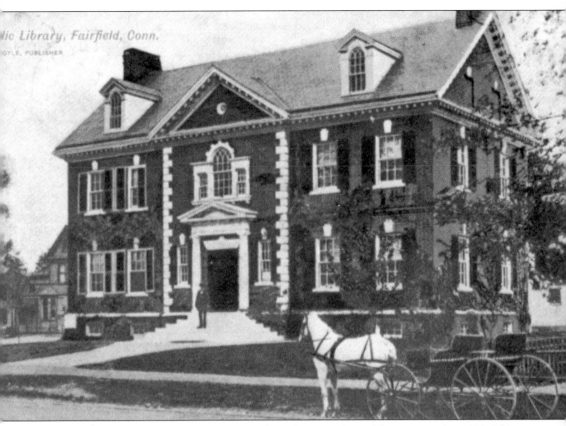

The library building was dedicated and opened its doors to the public on June 11, 1903. This postcard was mailed from Fairfield on October 6, 1909.

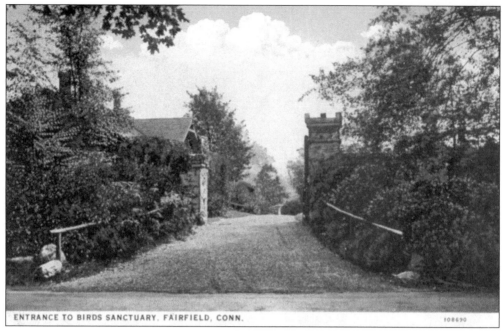

ENTRANCE TO BIRDS SANCTUARY, FAIRFIELD, CONN.

This is the entrance to what is now known as the Birdcraft Museum. In 1913, this Unquowa Road property was 10 acres of swampy pasture owned by Annie B. Jennings.

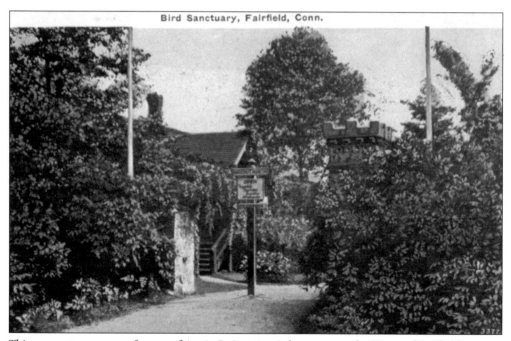

Bird Sanctuary, Fairfield, Conn.

This property was one of many of Annie B. Jennings's bequests to the Town of Fairfield.

Mabel Osgood Wright—daughter of the Reverend Samuel Osgood, who preached from his pulpit on the rock diagonally across the street—was chosen by Annie B. Jennings to develop a bird sanctuary. The sanctuary was also financed by Annie B. Jennings.

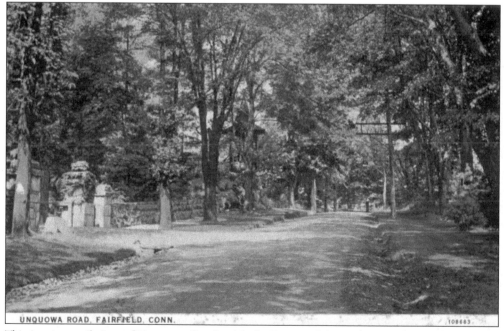

UNQUOWA ROAD, FAIRFIELD, CONN.

This is a tranquil view of Unquowa Road, with the Reverend Samuel Osgood's pavilion hidden among the trees (center). Today, this road receives considerably more traffic, as it now leads to Mosswood Condominiums, Tomlinson Middle School, the Fairfield train station, and downtown.

33

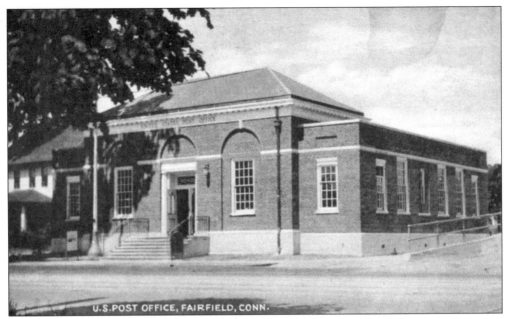

U.S. POST OFFICE, FAIRFIELD, CONN.

The post office was built in 1935 and was given an addition in 1964. The lobby mural reportedly depicts the marriage of John Hancock, the president of the Continental Congress, to Dorothy Quincy. Their reception took place at the Burr Homestead in 1775.

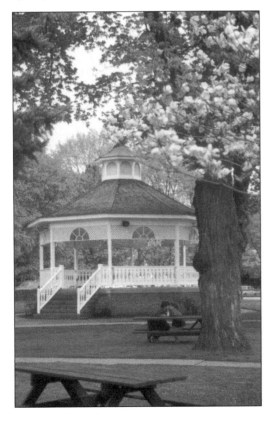

The town offers concerts throughout the summer. The concerts are held at the Sherman Green gazebo, built in 1985. (Courtesy of Ed Michaels.)

Three
BUSINESS AND
COMMERCE

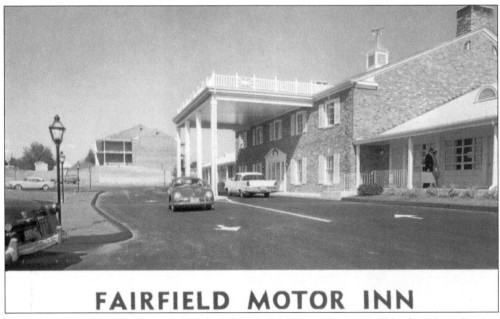

Today, cars like these are hard to find, but the Fairfield Motor Inn can still be found on the Post Road just beyond the traffic circle.

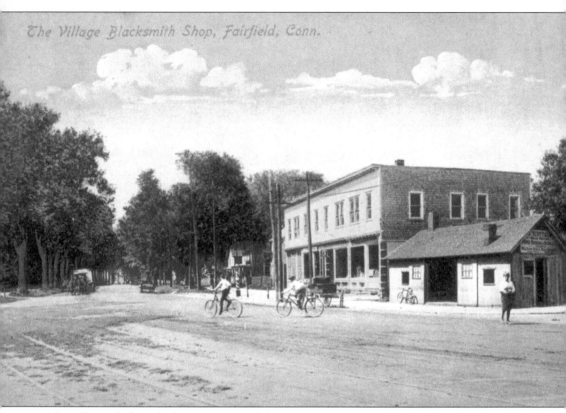

The Village Blacksmith Shop was originally located on land adjacent to the front yard of Sherman School, on Post Road and Reef Road. In 1871, it moved across the street to its final location: Post Road and Sanford Street. It closed in 1941.

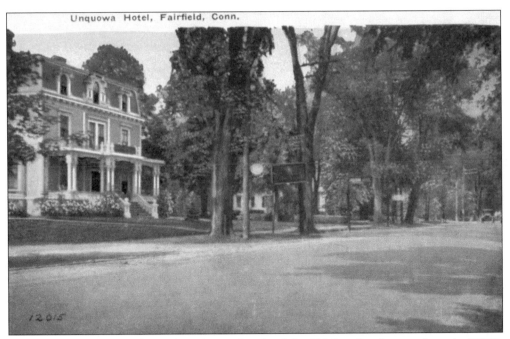

Unquowa Hotel, Fairfield, Conn.

The Unquowa Hotel was located on the north side of the Old Post Road across from the YMCA. The building was demolished in 1994. Only the foundation remains today.

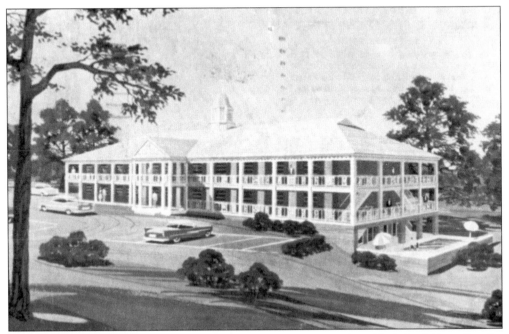

This is what was once known as the Merritt Parkway Motor Hotel on Black Rock Turnpike. On this card, mailed in September 1963, Lili writes to Louise, "Hi sweetie—sorry this isn't in color. The trees are starting to change color and it's beautiful up here."

This postcard was mailed on August 21, 1908, to A.T. Jennings of Greenfield Hill by the A.J. Benway Company of Fairfield. Its message is as follows: "This will remind you where to go when you are making plans to paint. We carry that reliable staple, Atlantic white lead, and all else required for a first class job. Let us figure out what you would need and its cost."

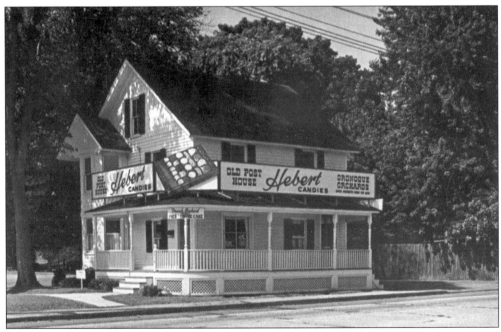

The Old Post House is located at 3519 Post Road in Southport. Now painted pink, it is home to a consignment store and model train store.

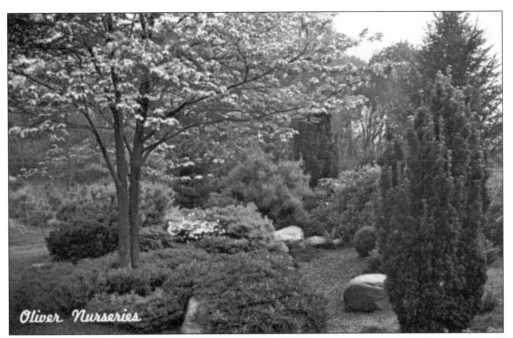

For 9¢ postage, plus the price of printing the postcard, direct advertising could not come much cheaper. In 1976, June was spring clearance month at Oliver's Nurseries, and the business was serving customers free coffee and doughnuts.

This is a postcard from the Angus Steak House. The card was never sent, but it dates back to when Joseph T. Dolan was president of the steak house.

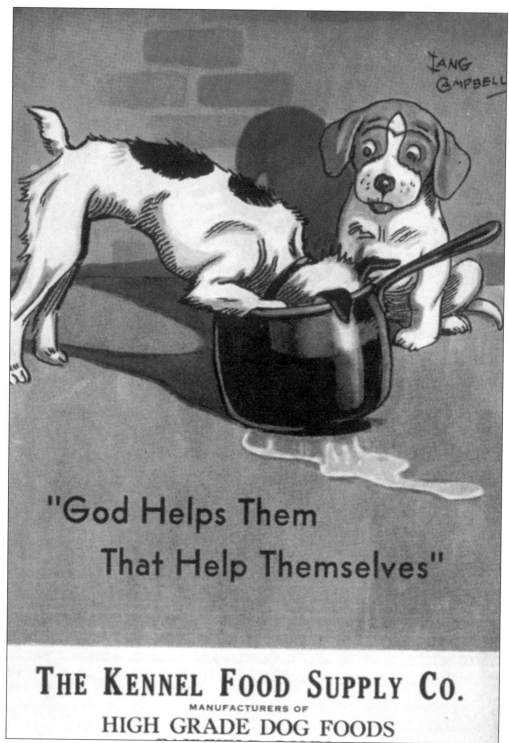

The Kennel Food Supply Company, founded and operated by Simon C. Bradley, was located on the Mill River near the Sturges Road bridge.

Four

SCHOOLS

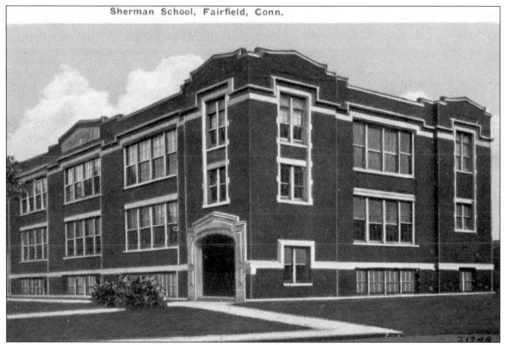

Sherman School, Fairfield, Conn.

Sherman School is located on Fern Street not far from the Fairfield Town Hall. In 1898, the Fairfield Town School Board decided at its August meeting that the children in town would salute the nation's flag every day.

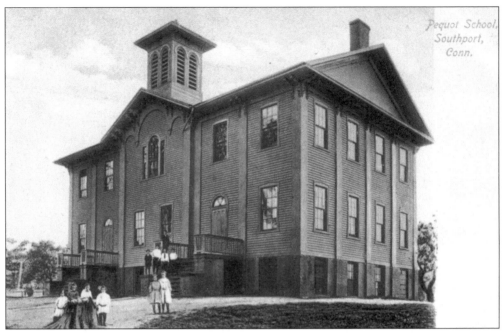

Pequot School was originally called Southport Public School; its name was changed in 1905. In 1943, Pequot became the first school to serve a hot lunch—at a cost of 15¢.

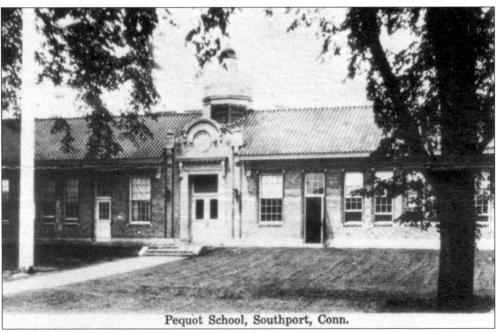

Pequot School, Southport, Conn.

School authorities declared June 3, 1884, a holiday for Pequot School pupils because the Greatest Show on Earth, Barnum and Bailey's Circus, was performing in Bridgeport.

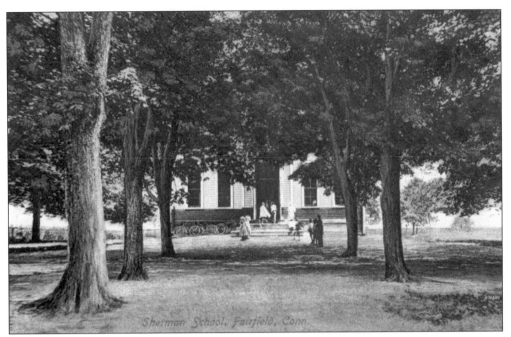

Sherman School originally stood on the corner of Reef Road and the Post Road in the area of the gazebo. In 1914, the first high school classes in Fairfield met in two of its rooms. Also in 1914, Sherman School was the first school to have a telephone installed.

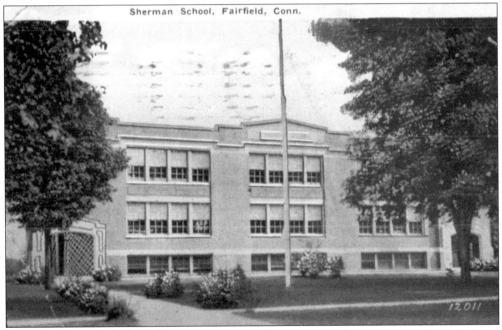

Sherman School was named in honor of Judge Roger Minot Sherman, an eminent jurist of Fairfield and the nephew of Roger Sherman, one of the signers of the Declaration of Independence.

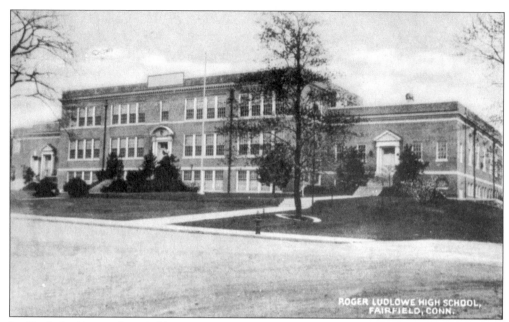

In 1916, the Town of Fairfield accepted, as a gift from Annie B. Jennings, the property where Tomlinson Middle School now stands. Originally, the property was the site of Fairfield's first high school. In 1918, the high school day was set from 9:00 a.m. to 2:45 p.m., with a half hour intermission for lunch.

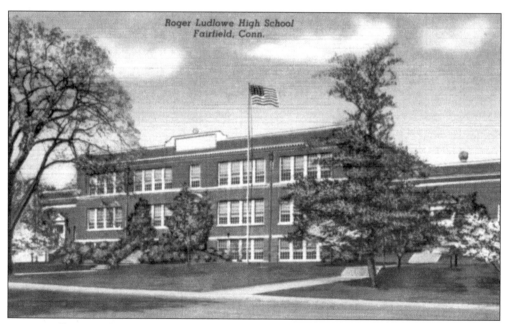

Roger Ludlowe High School was once home to the Flying Tigers. Postmarked September 25, 1949, this postcard was from Bobby to his parents in Biddeford, Maine: "This is the high school. Colors are orange and black like Biddeford. Odd, huh!"

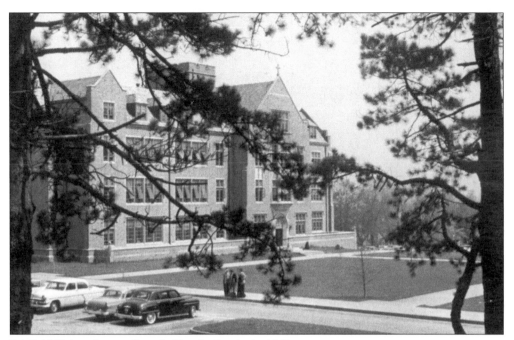

Fairfield University was founded by the Jesuits in 1942.

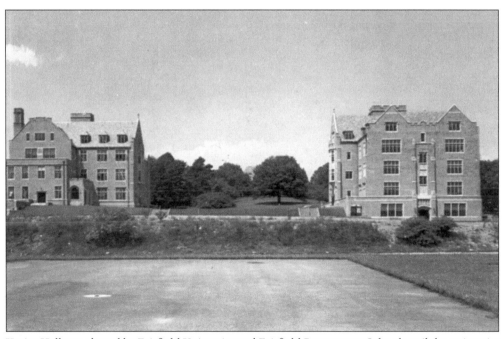

Xavier Hall was shared by Fairfield University and Fairfield Preparatory School until the university buildings were completed.

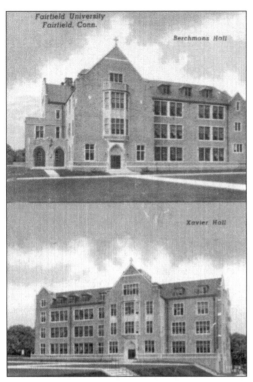

Xavier Hall was built in 1948 and is almost a mirror image of Berchmans Hall, which is just across the courtyard.

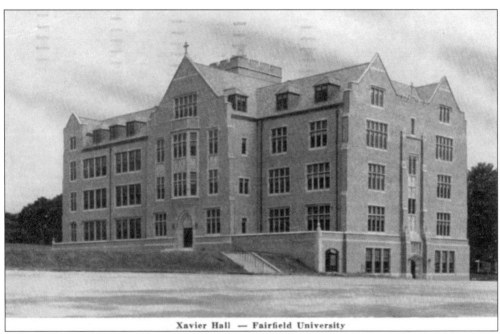

Xavier Hall — Fairfield University

Petie, who had some classes in Xavier Hall, wrote to Aunt Louise in 1965, "Wonderful challenge, nice people and excellent teachers. Age group 21–6? Education from bachelors through PhD. Have one psychiatrist in group. Get 9 credits toward my masters—very interesting being at Catholic school. Mass going on outside my window right now—Nuns are very nice."

Five
DID YOU KNOW?

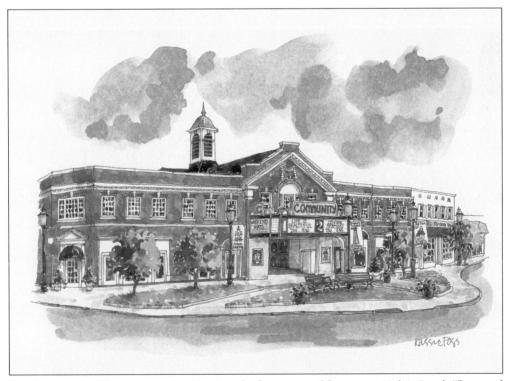

The Community Theatre occupies the site of a former pond known as Hide's Pond. The pond was named after Humphrey Hide who owned the property in 1660. (Courtesy of Kassie Foss.)

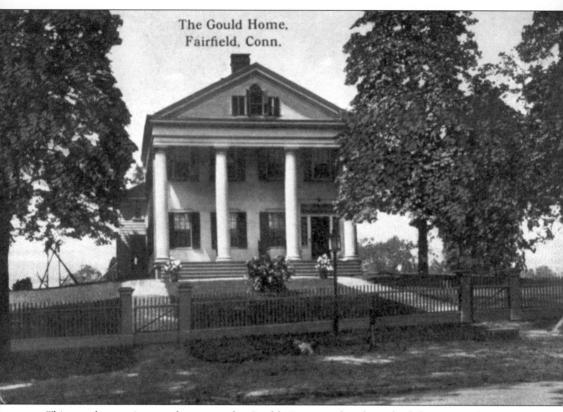

The Gould Home,
Fairfield, Conn.

This stately mansion was known as the Gould Homestead and was built by Capt. John Gould in 1841. The Gould Homestead was located in the vicinity of the Post Road and Old Kings Highway. It was demolished in 1955.

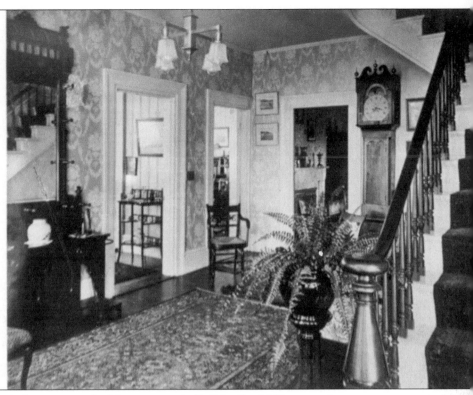

This is an actual photo postcard of the entrance hall of the Gould Homestead.

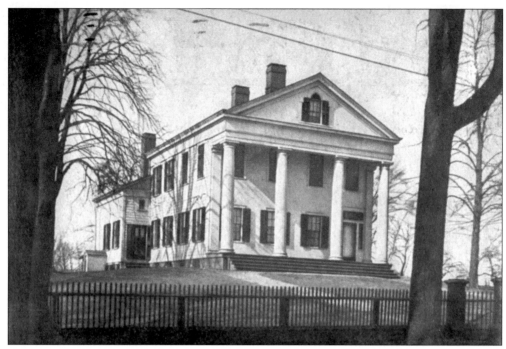

This home later became a summer home for women when the daughters of Capt. John Gould bequeathed their homestead and a major portion of their estate in trust for the purpose of maintaining "a free Summer Home for white, unmarried Protestant females between the ages of 18 and 50 years, who may be wholly dependent on their own labor for support and residing in the County of Fairfield."

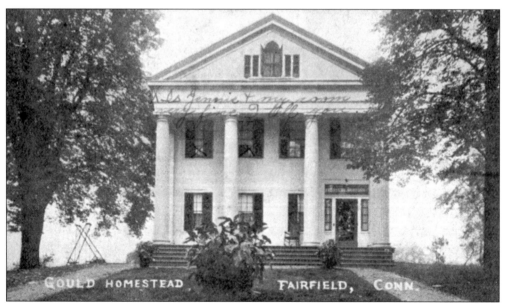

GOULD HOMESTEAD FAIRFIELD, CONN.

This postcard written by Ida to Mr. and Mrs. Caul in Bridgeport states that she is "having a fine time" and goes on to indicate where she and Jennie are staying by way of two *X*s in the second-floor windows on the left.

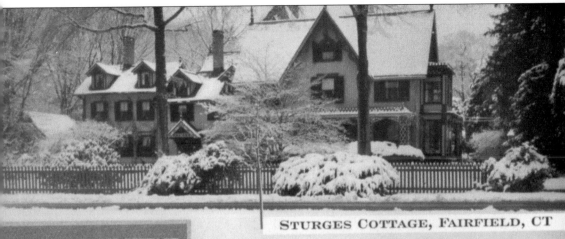

STURGES COTTAGE, FAIRFIELD, CT

Built in 1840 by Jonathan Sturges, "The Cottage" is one of the first wooden American Gothic houses built in this country. Six generations of descendants have occupied it and it is presently being lived in by Mary Bullard Rousseau and her brother, Henry Sturges Bullard, great-grandchildren of Jonathan Sturges.

Designed by an English architect, Joseph C. Wells, as a summer cottage for Mr. Sturges, it has grown to approximately 30 rooms with 11 staircases, 13 fireplaces and six stories, including the book tower.

The Sturges Cottage is located next to the Mill Plain Green. The founder of the Fairfield Historical Society, Henry Cody Sturges, resided here from 1846 to 1922.

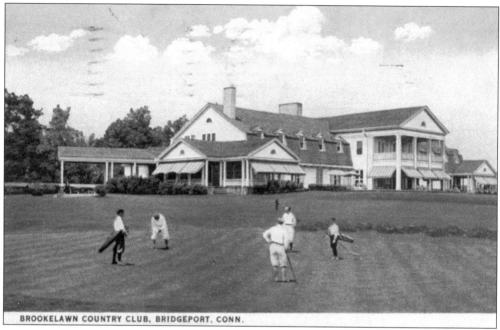

BROOKELAWN COUNTRY CLUB, BRIDGEPORT, CONN.

Brooklawn Country Club, located in the Stratfield section of Fairfield, was organized and incorporated in 1895. Although it was located in Fairfield, it was a Bridgeport organization.

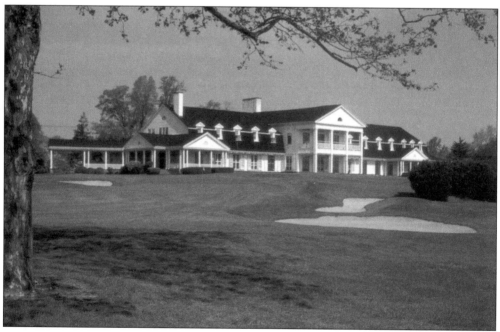

The exterior of the club really has not changed, as reflected in the postcard sent in 1924 (top) and this photo postcard taken in 1989. (Courtesy of Ed Michaels.)

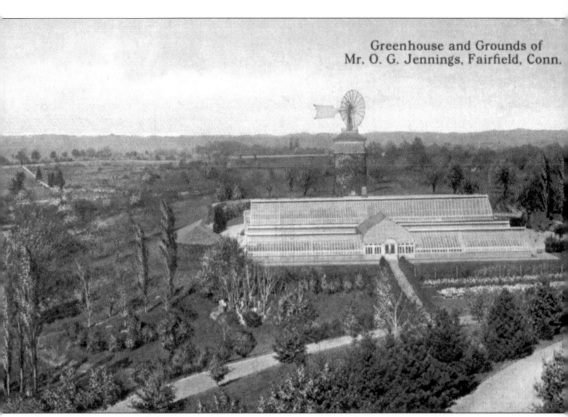

Greenhouse and Grounds of
Mr. O. G. Jennings, Fairfield, Conn.

This property, originally belonging to O.G. Jennings, was part of what later became Fairfield University.

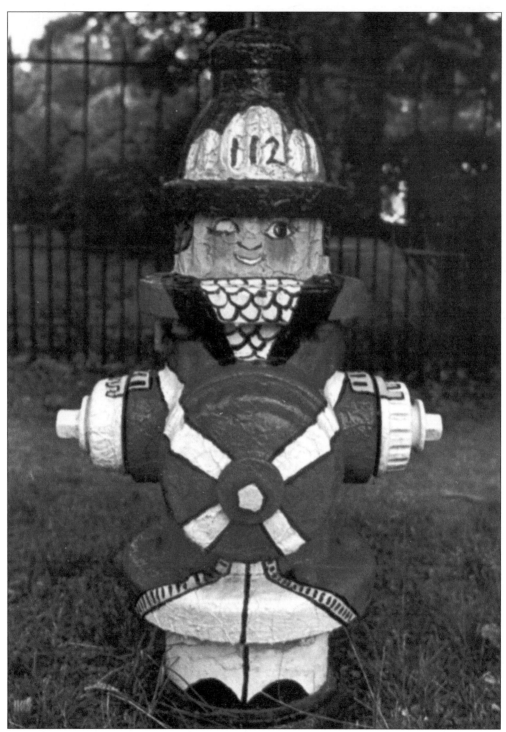

The Redcoats returned to Fairfield in 1976, when Jeanne Harrison transformed local fire hydrants into Revolutionary War soldiers in honor of our nation's bicentennial. (Courtesy of Jeanne Harrison.)

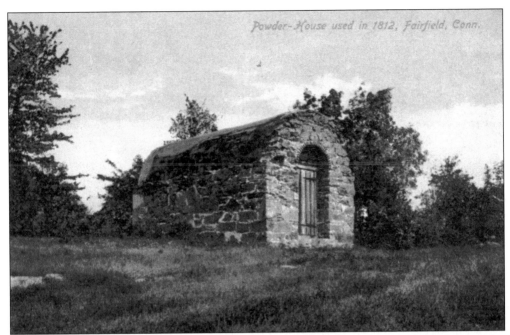

This powder house, which still stands behind Tomlinson Middle School, was originally built for the storage of munitions after the War of 1812.

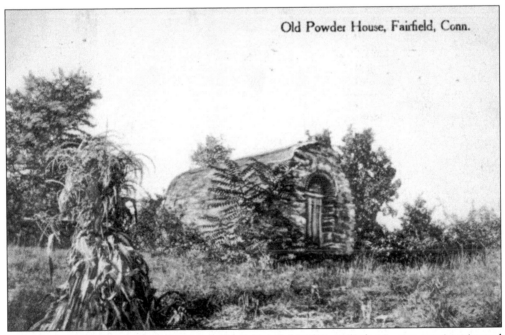

Elizabeth V.H. Banks reports in her book *This is Fairfield 1639–1940* that "a man was imprisoned here for misconduct. While he was in there, he drew his knife across the stone wall to see if it would spark. The officers valued the powder and since they feared an explosion they let him go free."

These four postcards of Fairfield are part of a large, statewide series of postcards that were made for Connecticut's 300th anniversary in 1935.

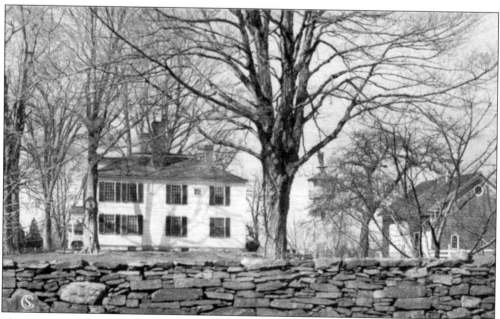

This view shows a stone wall in Greenfield Hill.

This picket fence is located in Fairfield.

The farm in this view is located in Greenfield Hill.

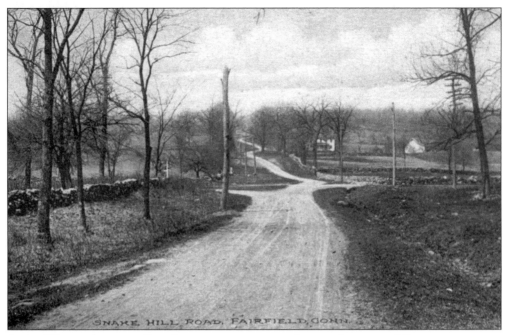
Snake Hill, now known as Burr Street, was once a popular spot for automobile races.

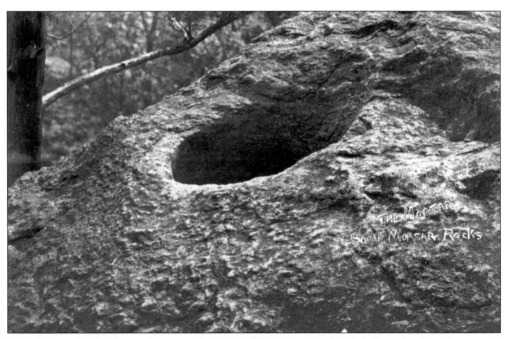
Samp Mortar Rock is located on a marked trail off Springer Road. It is believed to have been used by Native American women for grinding their corn into meal.

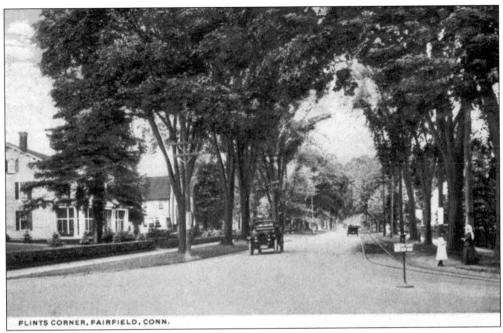

FLINTS CORNER, FAIRFIELD, CONN.

Flint's Corner is actually the point where the Old Post Road bends (near the YMCA and Oldfield Road) and leads to the library.

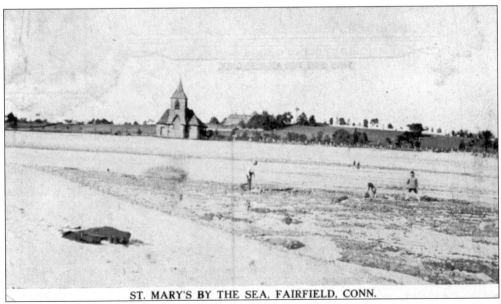

ST. MARY'S BY THE SEA, FAIRFIELD, CONN.

St. Mary's by the Sea was a church located on the west shore of Black Rock bordering Ash Creek from 1893 to 1925.

59

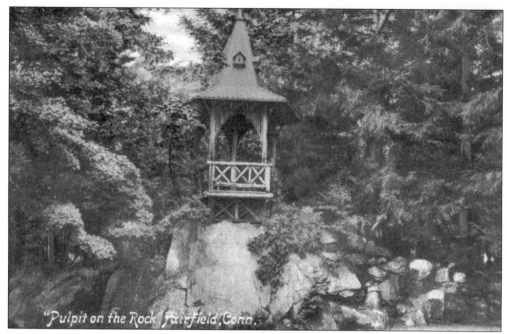

"Pulpit on the Rock, Fairfield, Conn.

This pavilion was built by the Reverend Samuel Osgood in the 1850s. He preached from this roadside pulpit during the Civil War. (Courtesy of Ruth Bedford.)

Interestingly enough, this is the reverse side of the card at the top of the page.

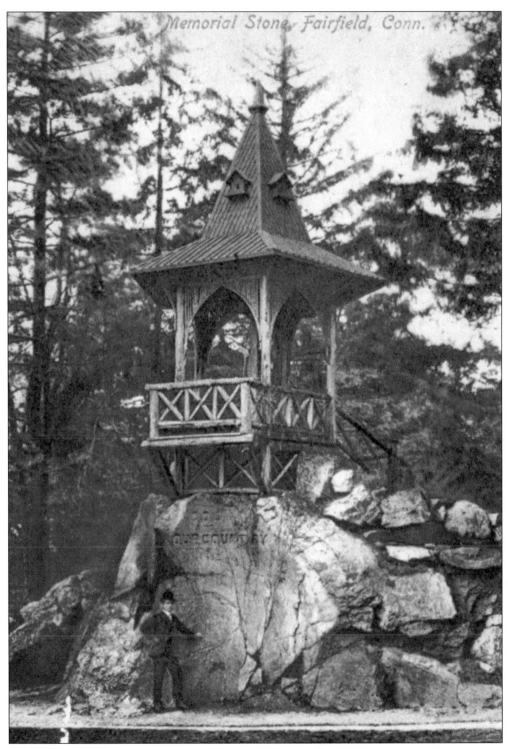

Pulpit Rock contains the inscription "God and Country 1862." This rock can be found on Unquowa Road near the entrance to Mosswood Condominiums.

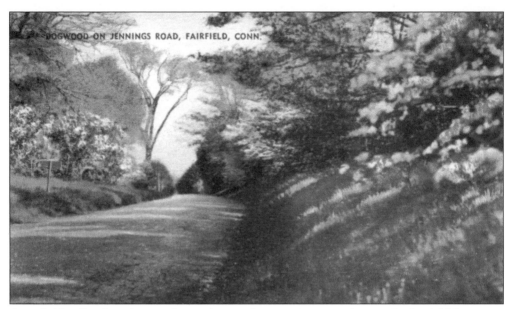

Greenfield Hill is best known for its dogwood trees. However, dogwoods also add beauty to many other roads in town, including Jennings Road.

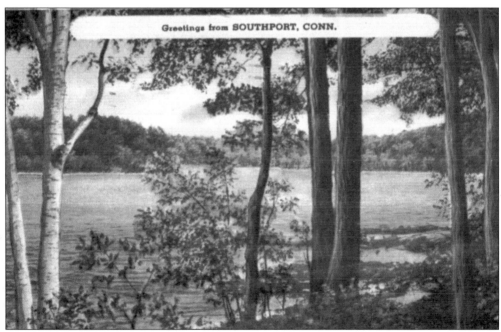

Despite the generic nature of this postcard, postmarked from Southport on September 18, 1950, the sender found Southport to be "a pleasant breath of fresh air."

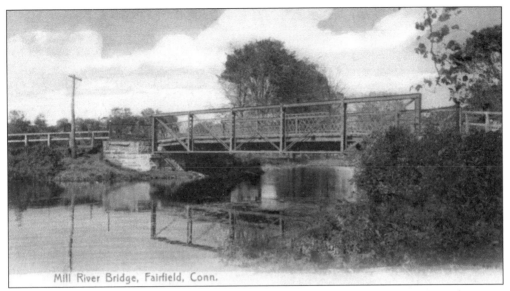

Mill River Bridge, Fairfield, Conn.

This iron bridge was removed in 1935 and replaced with a steel bridge with a stone face. It is located on Sturges Road at its intersection with Mill Hill Terrace.

Mill Plain looking North, Fairfield, Conn.

In 1872, a little green-and-white bandstand stood on the Mill Plain Green, where the town band played on Friday evenings twice a month. (Courtesy of William D. Lee.)

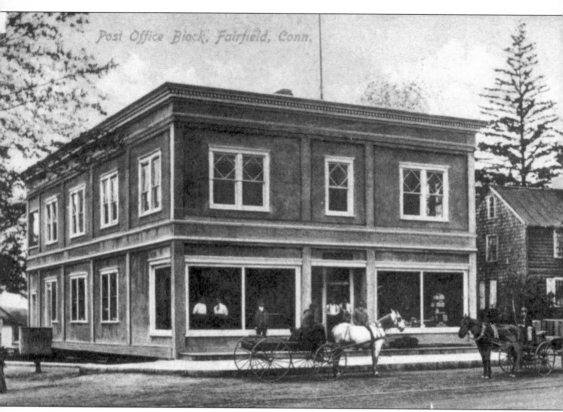

Post Office Block, Fairfield, Conn.

The post office was originally located at the corner of Reef Road and the Post Road. This postcard was mailed on September 30, 1912.

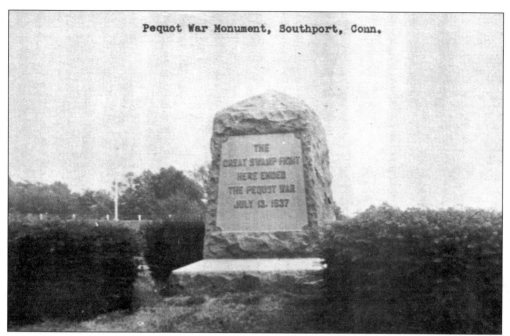

Pequot War Monument, Southport, Conn.

THE
GREAT SWAMP FIGHT
HERE ENDED
THE PEQUOT WAR
JULY 13, 1637

This monument, erected on the Post Road in the Southport section of town, commemorates the Great Swamp Fight, which ended the Pequot War on July 13, 1637.

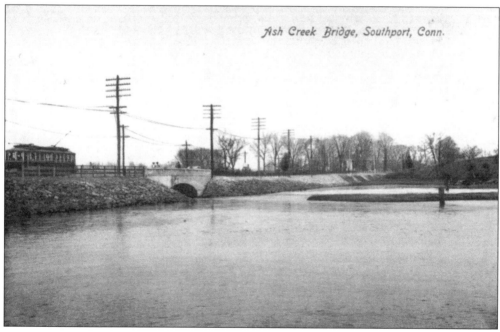

Ash Creek Bridge, Southport, Conn.

Actually, the Ash Creek Bridge is not located in Southport. It connects Fairfield and Bridgeport at Ash Creek where Fairfield becomes Black Rock. However, it is possible that the bridge on the Post Road in Southport, parallel to the Tide Mill Bridge, was once known as the Ash Creek Bridge.

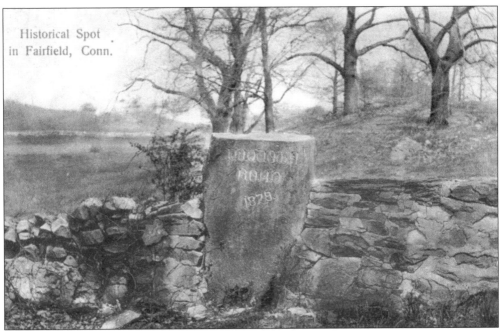

There will always be questions that go unanswered. Someone had to have known the significance behind the historical spot shown in the postcard above, with a stone that reads, "Unquowa Road, 1879." Someone must have known, too, specifically where the falls shown below are located.

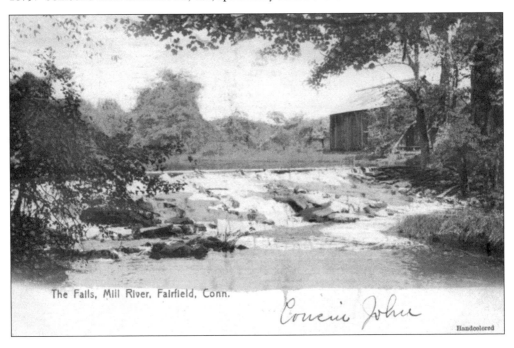

The Falls, Mill River, Fairfield, Conn.

Cousin John

Handcolored

66

Six

GREENFIELD HILL

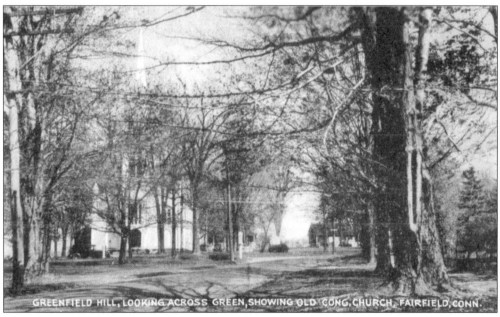

Over the years, many people have visited Greenfield Hill to see for themselves the beauty of the Dogwood trees in full bloom. In May 1938, Eleanor Roosevelt, wife of Pres. Franklin D. Roosevelt, came to Greenfield Hill to see the Dogwoods on her way from New York to Hyde Park.

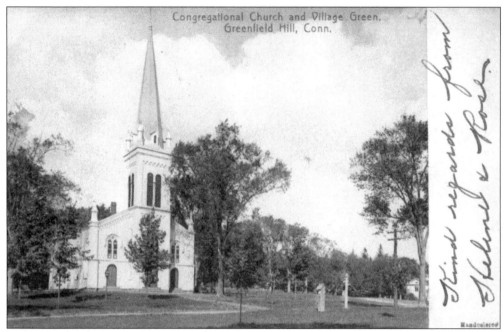

The church's steeple was blown off when a hurricane came through Fairfield on September 14, 1944. This postcard was mailed in August 1907 to Mrs. R. Kennel with kind regards from Helene and Rose.

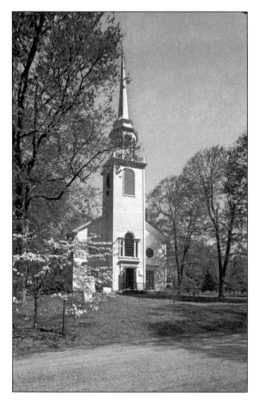

With the steeple rebuilt and the renovations complete, a service of rededication took place on May 19, 1946, the 220th anniversary of the founding of the church.

EENFIELD HILL, FAIRFIELD, CONN.

This sign that stands on the green next to the Greenfield Hill Congregational Church serves to remind all that in 1725, the parish of Greenfield, later called Greenfield Hill, was set aside.

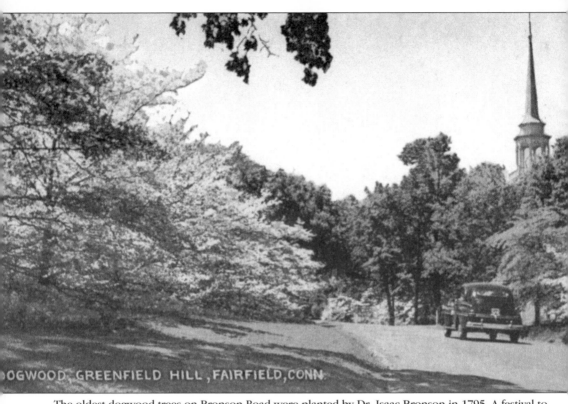

DOGWOOD, GREENFIELD HILL, FAIRFIELD, CONN.

The oldest dogwood trees on Bronson Road were planted by Dr. Isaac Bronson in 1795. A festival to celebrate their beauty is held each May on the grounds of the Greenfield Hill Congregational Church.

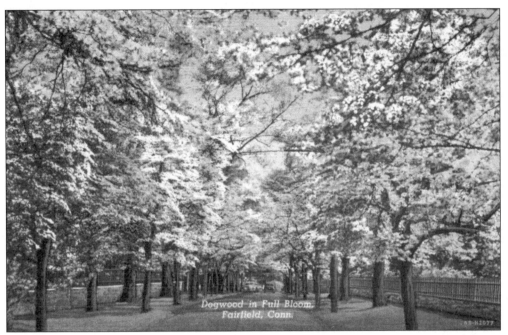

Old picture postcards are quite amazing to look at. The messages that they contain also can be fascinating to read.

When was the last time that you took your time, looked around town, and thought that this really is a beautiful place?

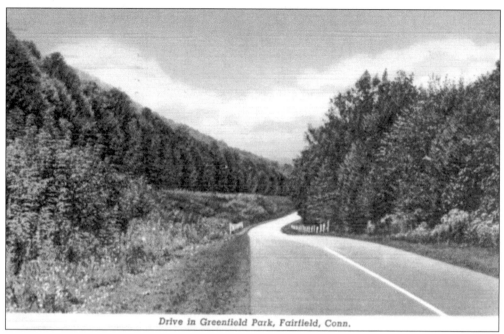

Drive in Greenfield Park, Fairfield, Conn.

On August 20, 1952, Adrie wrote to Mr. and Mrs. Robert Coan that "this is one of our prettiest drives in Connecticut."

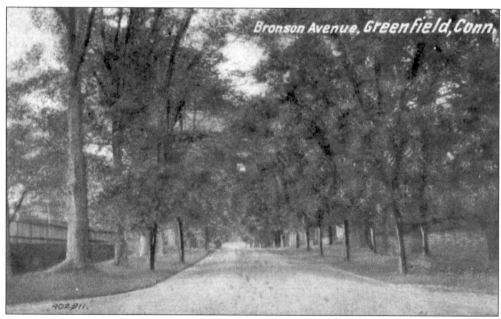

Bronson Avenue, Greenfield, Conn.

Town meeting records reflect that Dr. Isaac Bronson petitioned the town to allow a road to be established from Southport to Greenfield Hill. The petition was denied at first but later permitted. The road was initially known as Bronson Avenue, but is known today as Bronson Road.

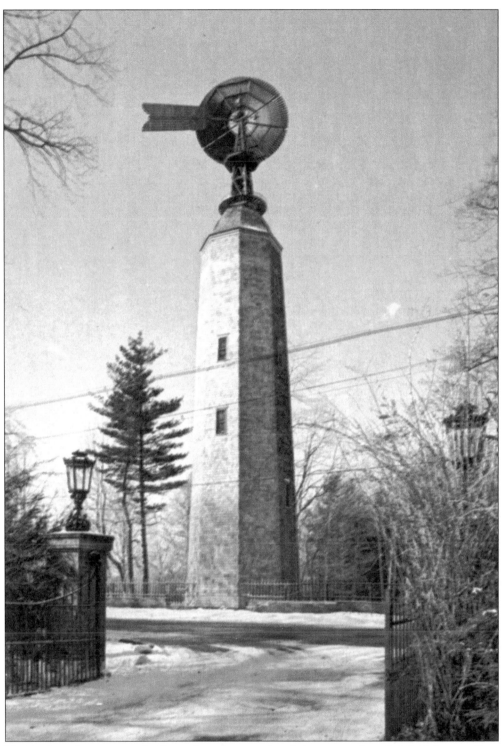

The Frederic Bronson windmill stands on Bronson Road, just across from Fairfield Country Day. The windmill, which was built in the last quarter of the 19th century, was restored in 1974.

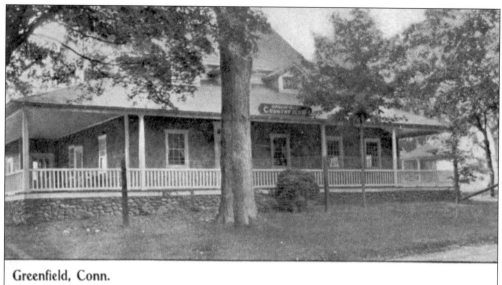

Greenfield, Conn.

Fair - 1905.

Bertha, Mary, Dorothy.

This is the Greenfield Hill Country Club. The club was established for the purpose of "affording opportunity for the study of agriculture, music and literature and promoting good fellowship and social improvement." It was located at the corner of Bronson Road and Verna Hill Road and is now a private residence.

Greenfield Country Club House, Greenfield, Conn.

This view from Verna Hill Road shows the large stone chimney, which was built from stones that each member of the club provided. The club was incorporated in 1902 and in 1903, nonresidents of Greenfield Hill were invited to join. Membership was extended to anyone within ten miles of the club.

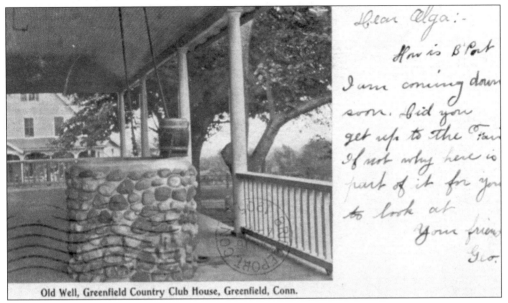

Old Well, Greenfield Country Club House, Greenfield, Conn.

This well was located on the club's south porch. In 1914, the club members voted to light the clubhouse with electricity.

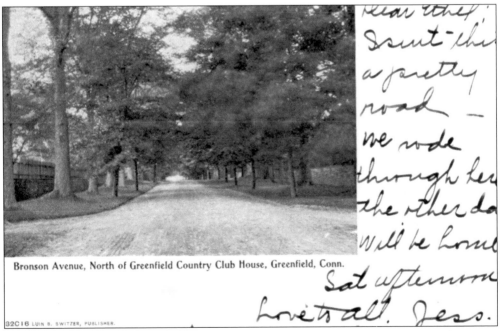

Bronson Avenue, North of Greenfield Country Club House, Greenfield, Conn.

Dr. Isaac Bronson planted the first white dogwoods. Some still stand at the corner of Bronson and Verna Hill Roads, the intersection that is pictured.

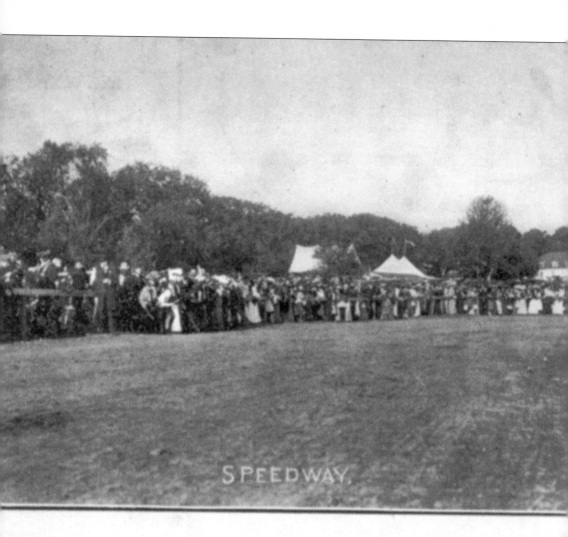

SPEEDWAY,

REENFIELD COUNTRY CLUB, GREENFIELD HILL, CON

The club boasted a quarter-mile racetrack with a grandstand—the envy of neighboring districts. The club's annual fair was such a success that it grew from a one-day event in 1901 to a four-day event in 1906. On August 30, 1909, the Fairfield School Committee voted "that the schools of the Town have Wednesday, September 15, or if stormy, the next fair day for attendance at the Greenfield Fair."

Seven
STROLLING
ON THE BEACH

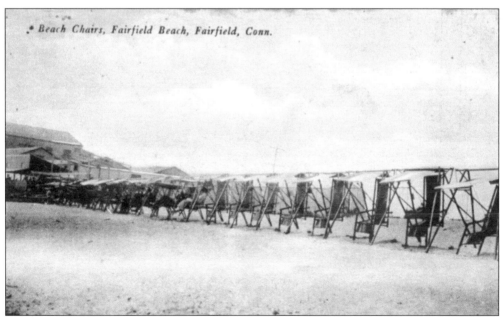

Beach Chairs, Fairfield Beach, Fairfield, Conn.

Fairfield is a community that boasts 8 miles of shoreline, including two miles of sandy beaches. Despite the fact that these chairs do not look very comfortable, there are beachgoers sitting in some of them.

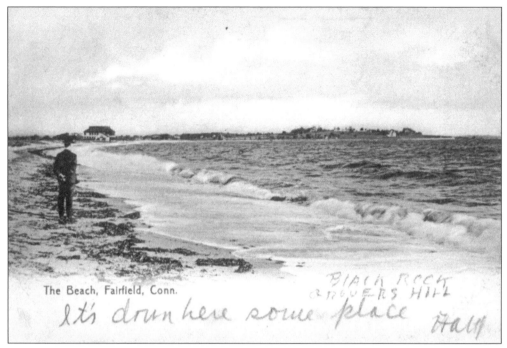

The Beach, Fairfield, Conn.

BLACK ROCK GROVERS HILL
It's down here some place
Haly

The beach known today as Jennings Beach was once beach property of Annie B. Jennings. In 1934, she gave this beach, which adjoined her property, to the Town of Fairfield.

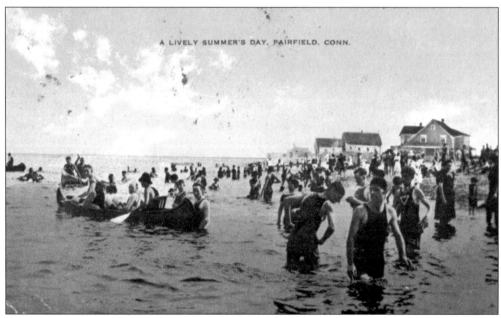

A LIVELY SUMMER'S DAY, FAIRFIELD, CONN.

In July 1916, Marion, who was staying at Bide A Wee Cottage on Fairfield Beach, wrote to Miss Allen, "Having a gorgeous time. Eat, fish, swim & dance. Corking! Some beach. Sorry I couldn't see you on picnic, but was awfully busy."

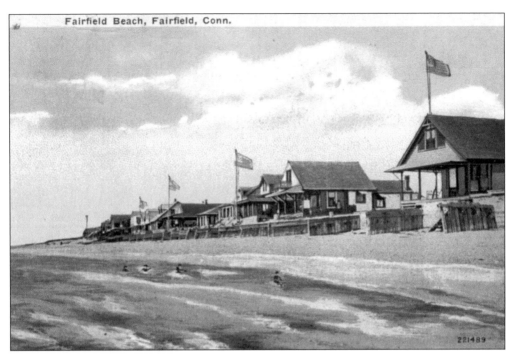

On August 18, 1921, Gwendolyn wrote from her accommodations at 179 Happy Days Cottage on Fairfield Beach, "We are having a dandy time and like it here lots."

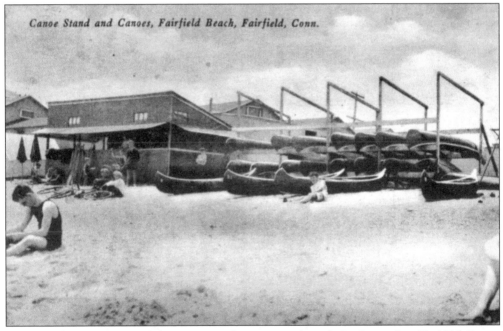

One visitor to the beaches did not seem to be quite as pleased. On September 30, 1926, Emma wrote, "Having a fine time, this is a very nice place, was in swimming today, so different than fresh water, just the same I like ours the best."

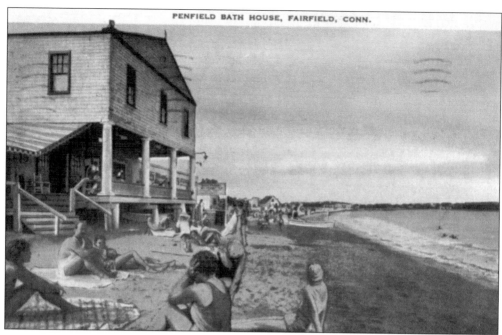

On July 26, 1938, a little girl named Louise wrote to Junior, "We saw a whole bunch of crabs—almost a hundred. Having a nice time swimming with my tube."

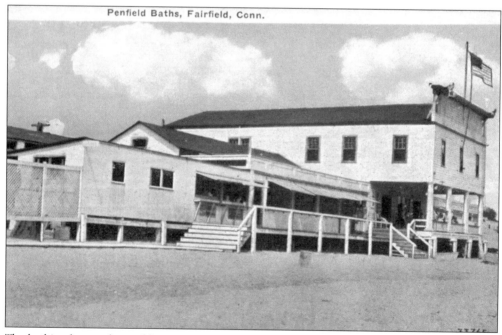

The bathing houses located here were rented out by the Penfield Reef Corporation annually.

LEASE

This Indenture, made by and between THE PENFIELD REEF CORPORATION, of the town of Fairfield, party of the first part, and Jennie Dickie, of Bridgeport, Con., party of the second part, WITNESSETH:

That said party of the first part has leased and does hereby lease to the said party of the second part one bathing house known as No. 44 , located in the Penfield Reef Corporation's Bathing Pavilion, in the Town of Fairfield, for the season of 1920 , said season to begin June 15, 192 0 for the rental of $ 25.00 , payable in advance.

It is understood and agreed by the party of the first part and the party of the second part that said bath house may be used by the party of the second part and his or her immediate family only. Any violation of this provision shall forfeit the lease of said house and all moneys paid for said rental shall be considered as payment for the time said house has been used.

In Witness Whereof, we have hereunto set our hands and seals this 31st day of May 1920

will pay the June

Jennie Dickie
Penfield Reef Corp
H. Weir Goldsborough, Sec'y

For the 1920 beach season, Jennie Dickie of Bridgeport rented bathing house No. 44 for $25, as indicated by her signed lease.

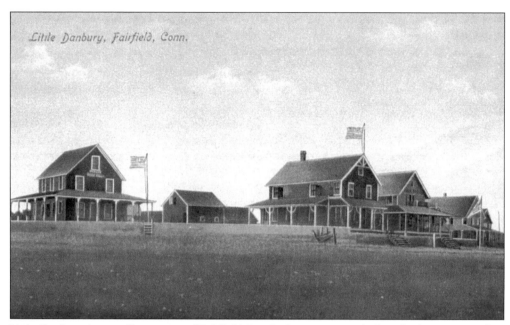

Little Danbury is actually an area of Fairfield Beach that was named after the hometown of its summer residents. (Courtesy of William D. Lee.)

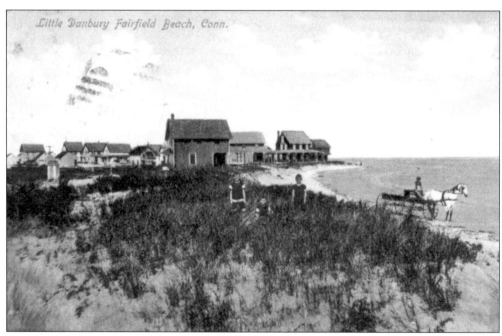

Carrie's mother sent her this postcard on June 23, 1910. She was staying at Beach Croft: "Having a good time, plenty to eat."

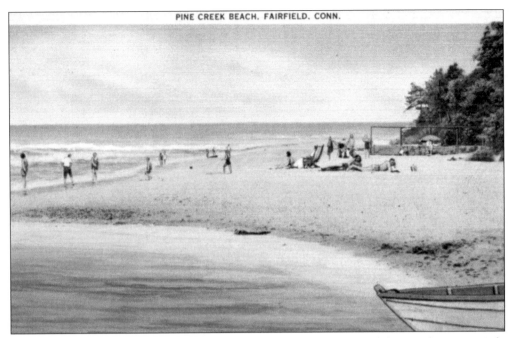

In the late 1800s, a settlement of summer homes along Pine Creek Beach became known as Little Bridgeport, where individuals of moderate means from Bridgeport established second homes in Fairfield.

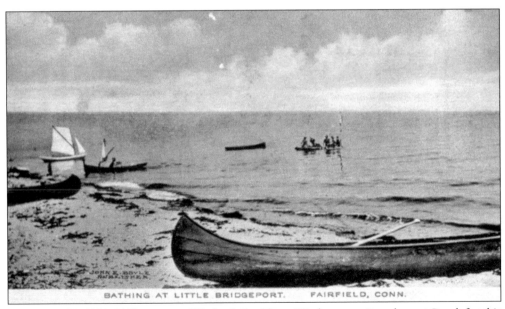

BATHING AT LITTLE BRIDGEPORT. FAIRFIELD, CONN.

On August 21, 1903, M.H. wrote to Elizabeth Conkling, "We have a cottage here at Beach for this week. It's great sport. Clams galore for the digging."

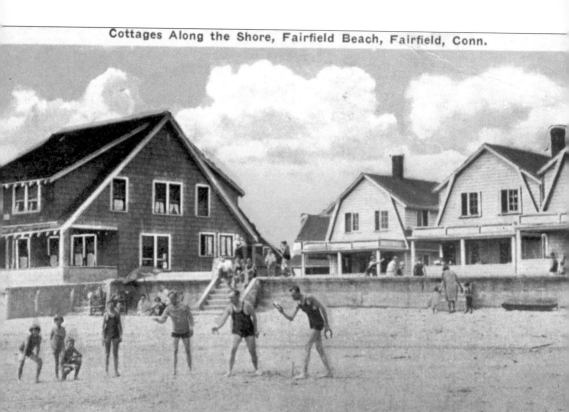

William D. Lee Sr. states, "While previously viewing Beth Love's marvelous collection of postcards and being a collector myself, there is that special occasion of a wonderful new discovery. I immediately recognized the people enjoying this warm summer day on Thorp's Court beachfront in this early 20th century card. With a more careful study, I discovered myself as well sitting on the beachfront wall."

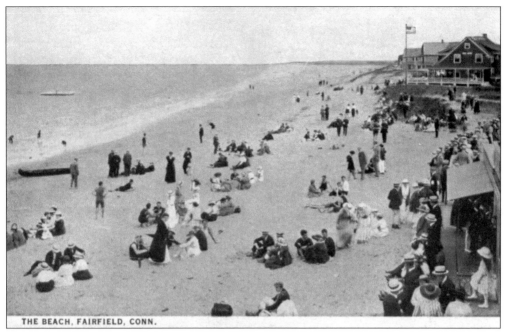

THE BEACH, FAIRFIELD, CONN.

The beaches of Fairfield have always been a popular gathering spot. In 1922, just two years before the postmark on this postcard, one of the headlines of the *Fairfield News* read, "Popular Bathing Girl Contest—Shirley O'Connor—9 year-old miss is Acclaimed Most Popular Girl at Beach."

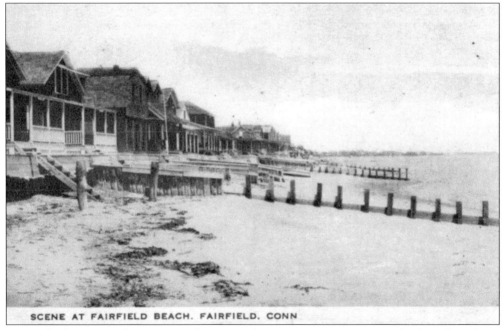

SCENE AT FAIRFIELD BEACH. FAIRFIELD. CONN

On April 26, 1929, Karl wrote to Wallace in Michigan, "Here I am again at this fine place doing some more photo work on a beautiful place which contains many rare pieces of furniture, prints, china, etc. Great trees here like Newport. Has been hot but better today."

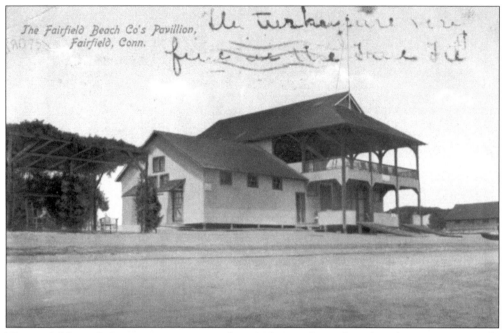

The Fairfield Beach Company was organized in 1886. One share of stock in the company initially cost $50 and entitled the shareholder to a bathhouse.

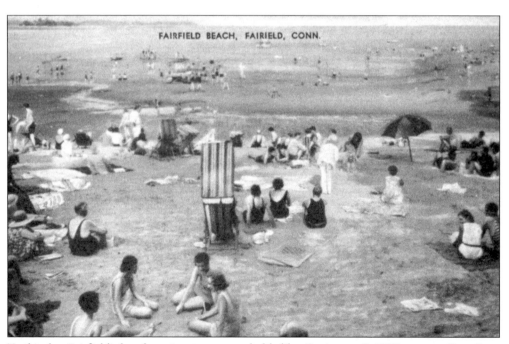

To this day, Fairfield's beaches attract young and old alike. On August 9, 1938, a young Betty Jane wrote to Aunt Jane, "This is Fairfield Beach. Today it is raining—this afternoon I mean. We are all having a fine time."

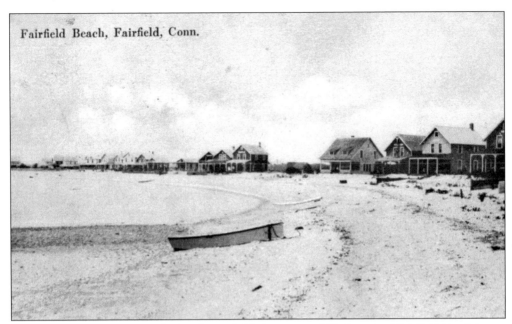

Fairfield Beach, Fairfield, Conn.

Frank Samuel Child stated in his book *Fairfield: Ancient and Modern* that "Fairfield Beach is one of the safest and most attractive along the shores of the [Long Island] sound."

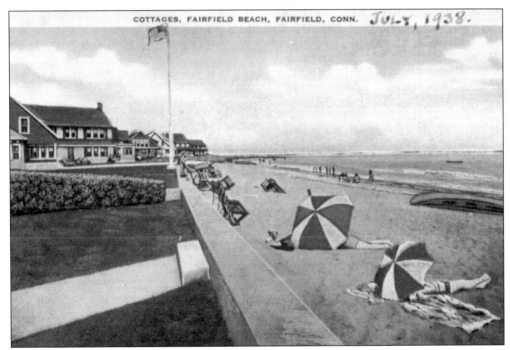

COTTAGES, FAIRFIELD BEACH, FAIRFIELD, CONN. *July, 1938.*

On July 27, 1938, Uncle Bill wrote to Libby, "Went in swimming here It was simply great." The following year, the beaches were restricted to Fairfield residents only.

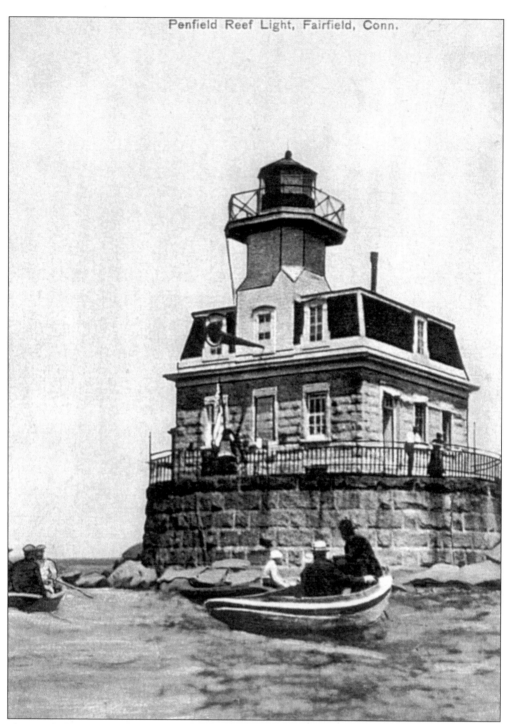

Penfield Reef Light, Fairfield, Conn.

The Penfield Reef Lighthouse was built in 1874 and was placed on the National Register of Historic Places in 1990. The 51-foot-tall lighthouse has a light with a 12-mile range. Although located approximately one mile off Penfield Beach, a dispute currently exists as to whether it is located in Fairfield or Bridgeport. (Courtesy of William D. Lee.)

Eight

DOWN BY
SOUTHPORT HARBOR

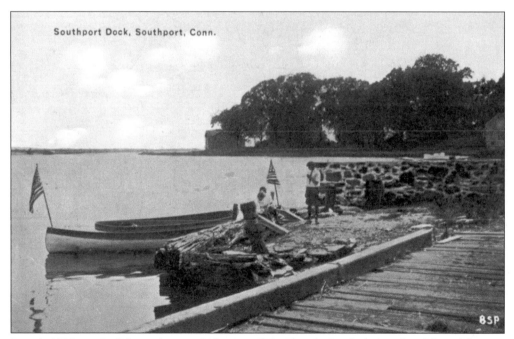

Southport Dock, Southport, Conn.

BSP

June 3, 2000, marked the sixth annual Blessing of the Fleet in Southport Harbor. The celebration included the dedication of the Historic Lower Wharf at Southport Harbor.

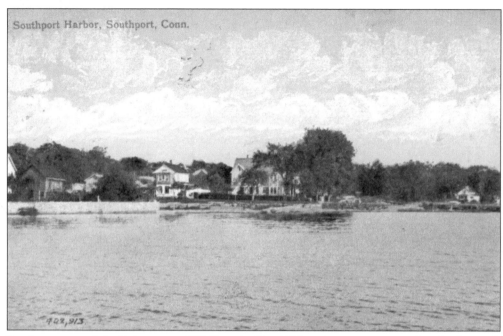

Southport was originally known as Mill River. In May 1831, a charter was granted to the Borough of Southport. This postcard was postmarked September 12, 1911.

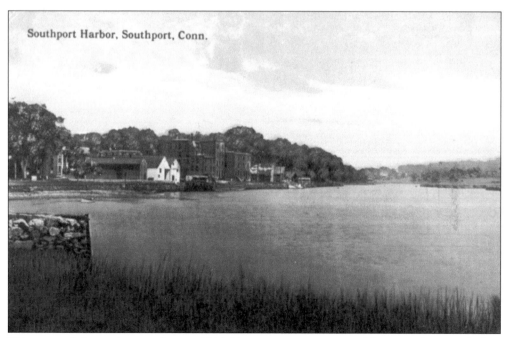

This postcard shows the waterfront *c.* 1914. Many crops were exported from Southport including grain, apples, hay, rye, flour, and onions.

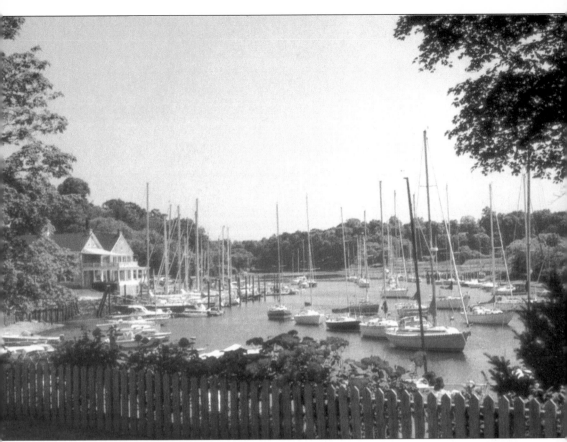

This postcard shows Southport Harbor in 1989. Southport is no longer a farming community and with no crops to export, Southport Harbor's chief use is recreational. (Courtesy of Ed Michaels.)

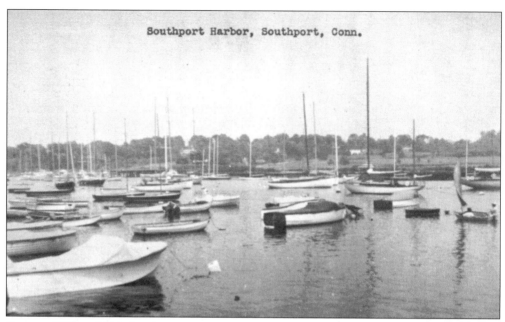

Southport Harbor, Southport, Conn.

From c. 1820 to 1880, Southport was a major port. It was largely devoted to exporting farm produce, mainly onions.

Main Street Looking Toward Harbor, Southport, Conn.

In 1903, the last schooner loaded with onions left Southport Harbor.

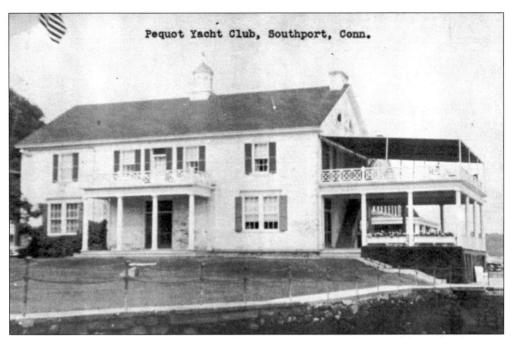

On October 25, 1920, the first meeting of the Pequot Yacht Club took place at the home of Frederick T. Bedford in Greens Farms. The nine gentlemen in attendance agreed to become members of a yacht club for the purpose of reviving and furthering interest in the sport.

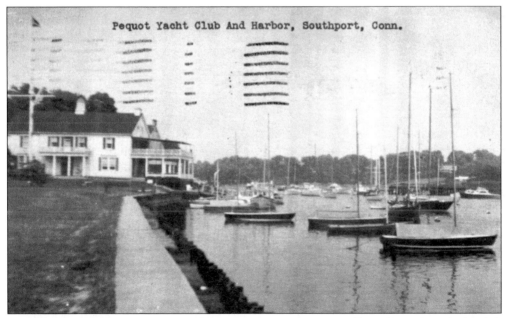

In November 1920, a constitution and bylaws were drawn up and officers were elected. The club had 33 members, with dues set at $25 annually.

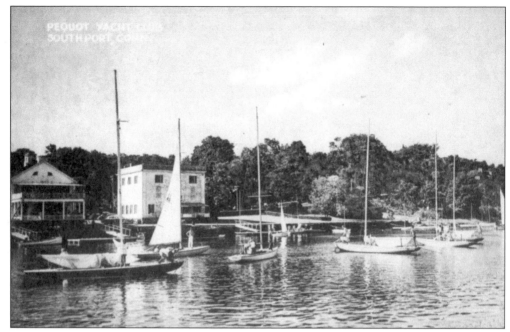

In 1923, the club sponsored the first junior regatta in the Yacht Racing Association of Long Island Sound for crews 18 years of age and under.

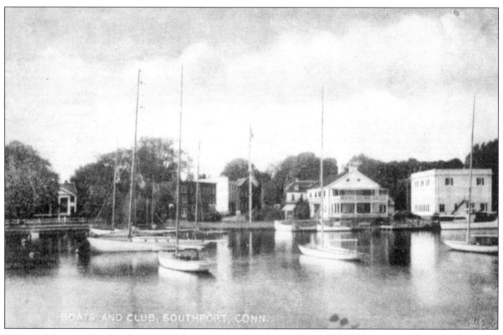

The club began the first formal junior program in the summer of 1924.

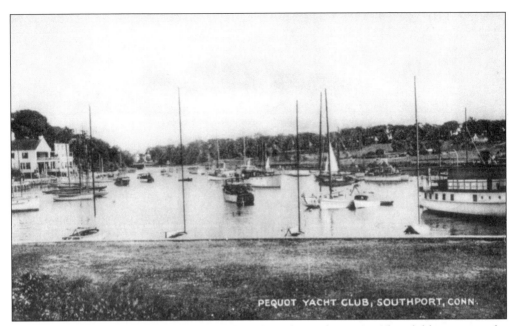

The Pequot Junior Yacht Club was developed in the early 1930s. The clubhouse was the Wakeman Memorial Building on Harbor Road.

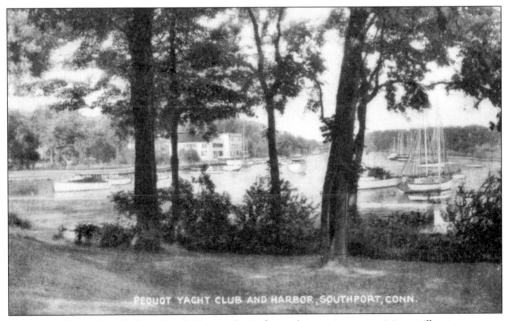

The 1950s brought a shift in the club's emphasis from class racing to cruising sailboat.

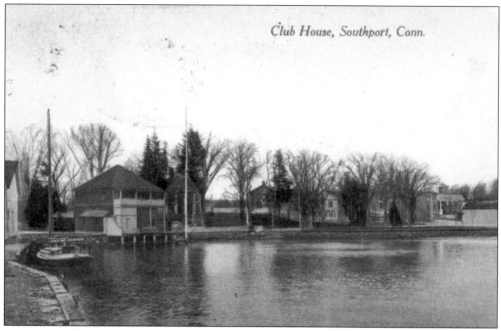

Club House, Southport, Conn.

This property at the foot of Westway Road was originally town-owned and was sold in 1765 to William Bulkley, who built a store. Over the years, it became a dry goods store and a meat market.

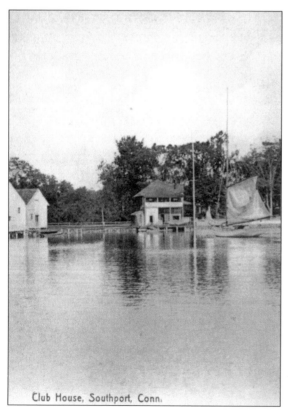

Club House, Southport, Conn.

In 1894, it was bought by Bachelor's Comfort and Married Man's Relief Club for use as a clubhouse.

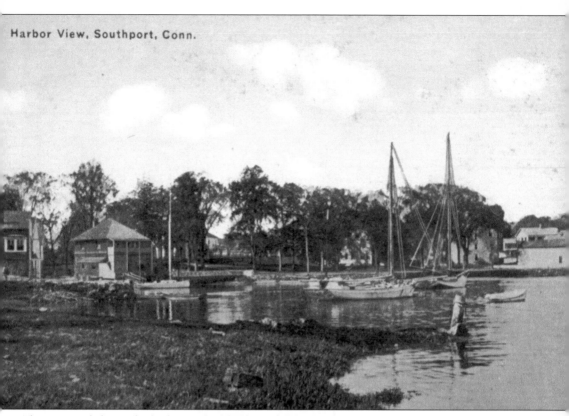

This postcard shows the harbor just at the foot of Westway Road, with the clubhouse to the left.

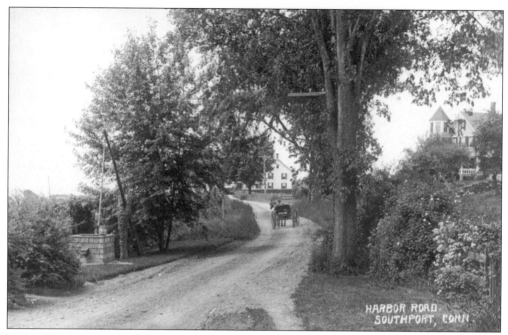

Harbor Road was originally known as Water Street.

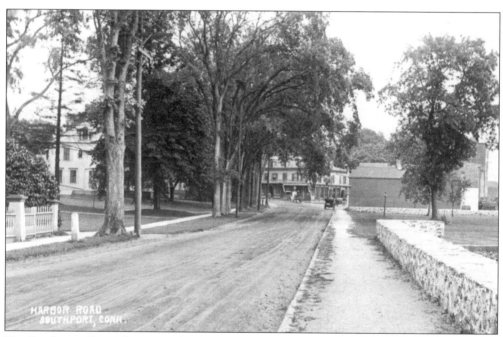

The *Southport Chronicle* reported in its April 18, 1893 edition that "Harbor Road is the most desirable land in the village commanding a magnificent view of the water."

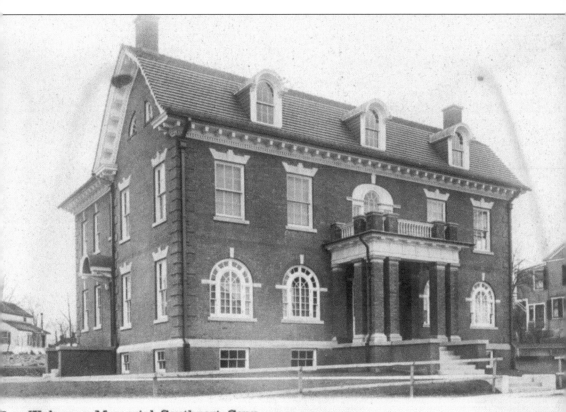

2 **Wakeman Memorial, Southport, Conn.**

This building, located at 668 Harbor Road, was constructed in 1913 by Frances Wakeman and Cornelia Wakeman Grapo, in honor of their grandfather Jesup Wakeman, "for the betterment and uplift of the girls and boys of the village." The club moved to its present location in 1954.

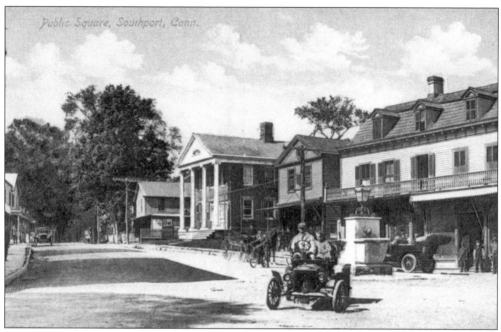

This is the Southport Public Square, Main Street at Harbor Road, as it appeared in the early 20th century. The fountain was installed in 1903, and this postcard was postmarked in 1909.

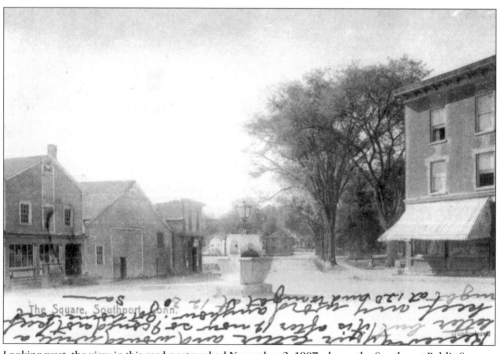

Looking west, the view in this card postmarked November 2, 1907, shows the Southport Public Square.

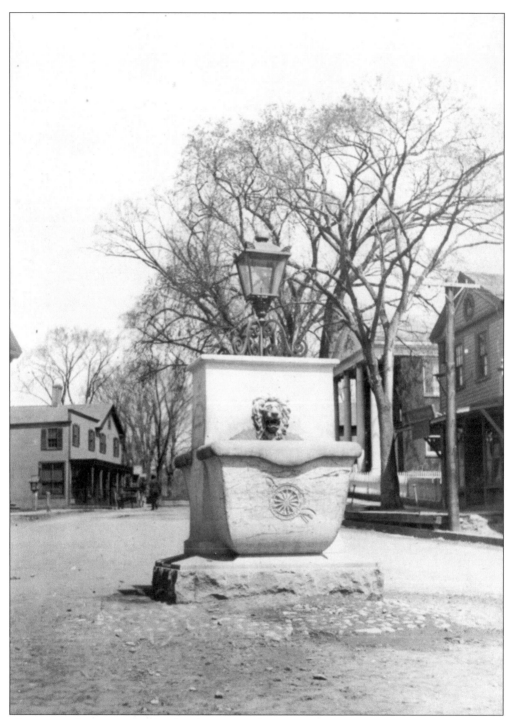

This granite fountain was placed at the corner of Main Street and Harbor Road by the Daughters of the American Revolution in 1903. It commemorates the Pequot Indian Swamp Fight in 1637. Originally, the large troughs on the north and south sides were for horses, the fountain on the right side was for people, and the fountain at the base on the left side was for dogs.

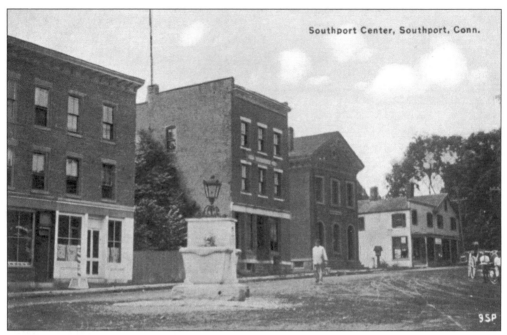

This postcard shows the original Southport Center, just across the street from the harbor.

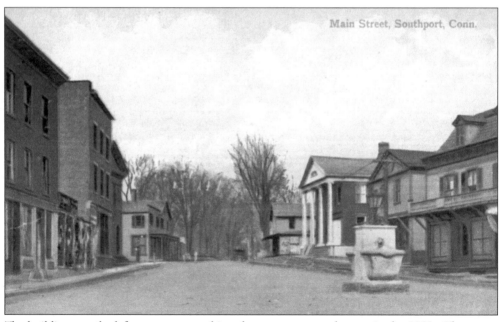

The buildings on the left were converted into luxury apartment houses in the 1950s. They were originally tenements, with stores and offices on the first floor.

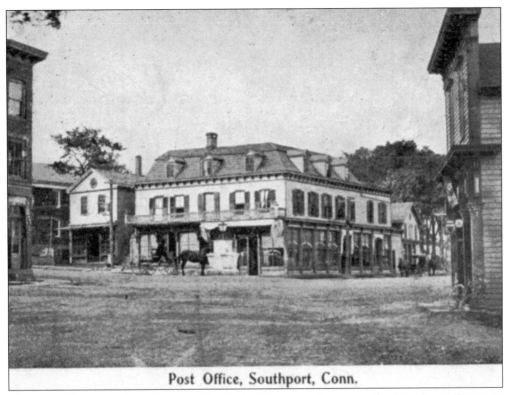

Post Office, Southport, Conn.

The post office was originally located in the building once known as the Mian Perry House on the corner of Harbor Road and Main Street. The post office was relocated to Pequot Avenue in 1926.

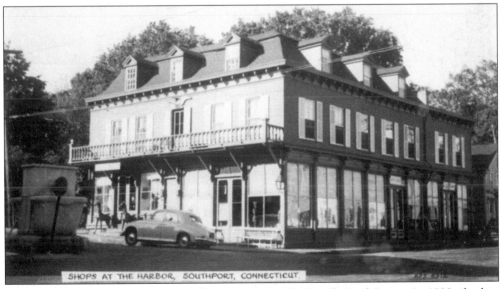

SHOPS AT THE HARBOR, SOUTHPORT, CONNECTICUT.

The Mian Perry House is now the office of Nicholas H. Fingelly Real Estate. In 1992, the late Nicholas Fingelly was presented with the Southport Conservancy Distinguished Achievement Award for this building's historic restoration.

103

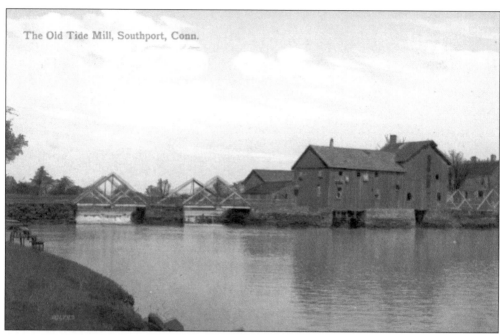

The Old Tide Mill, Southport, Conn.

The Tide Mill building sits on the site of the first gristmill in the Southport area. It was one of only a few that operated by using the tide.

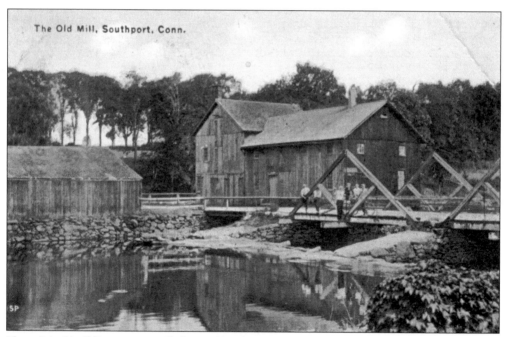

The Old Mill, Southport, Conn.

The original building was partially burned by the British during the Revolutionary War, but it was rebuilt on the same timbers. Its use as a mill continued until 1915, when the gristmill was operated for the last time by Miller Alva R. Kelsey.

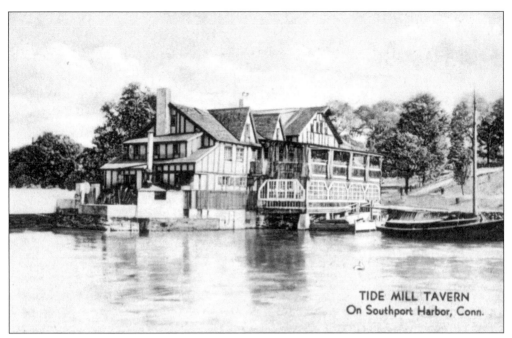

TIDE MILL TAVERN
On Southport Harbor, Conn.

In 1924, the Tide Mill Tavern opened for business. It then became an expansion of the Spinning Wheel Inn in Redding and was renamed the Spinning Wheel Mill, operating as such from 1942 to 1955. Over the years, the restaurant also operated under the names Mill River Inn and Tide Mill Inn, as it was last known before it closed in 1960.

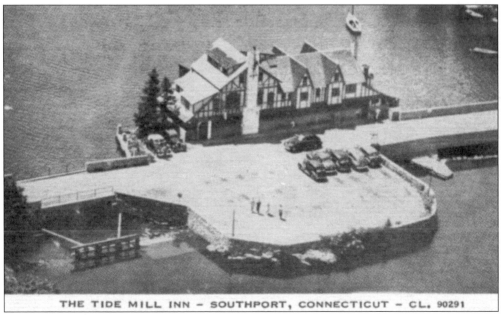

THE TIDE MILL INN – SOUTHPORT, CONNECTICUT – CL. 90291

In addition to being the only restaurant in the harbor area, the inn offered harbor views, guest rooms for those who wished to spend the night, and verandas where meals and refreshments were served. No alcoholic beverages were sold on the premises, as several attempts over the years to obtain a liquor license were unsuccessful.

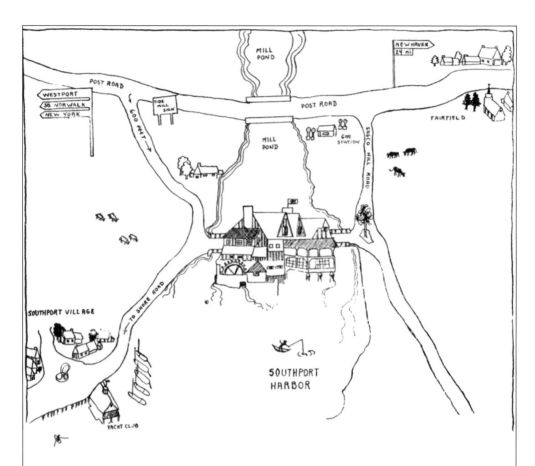

TIDE MILL TAVERN

A Connecticut inn of sea-faring atmosphere

ON SOUTHPORT HARBOR

offers the best lunch and dinner on the Connecticut Shore
for those going to and from the game

FEATURING

for those in a hurry

A HOT BUFFET SERVED IN THE GAME ROOM

11:00 A. M. until 10:00 P. M.

"ALL YOU CAN EAT FOR $1.25"

In addition to our regular menus served in the old tap room

This advertisement for the Tide Mill Tavern appeared in the Army-Yale football program on October 26, 1935. (Courtesy of William D. Lee.)

This is an actual matchbook cover advertising the Tide Mill Tavern in the 1930s.

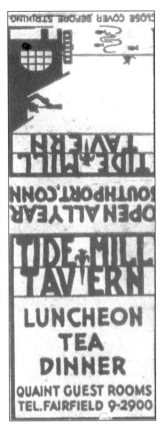

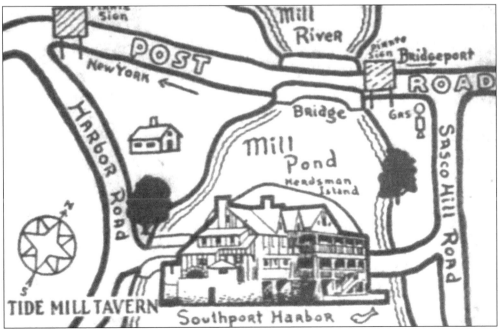

The inside cover of the matchbook featured this map.

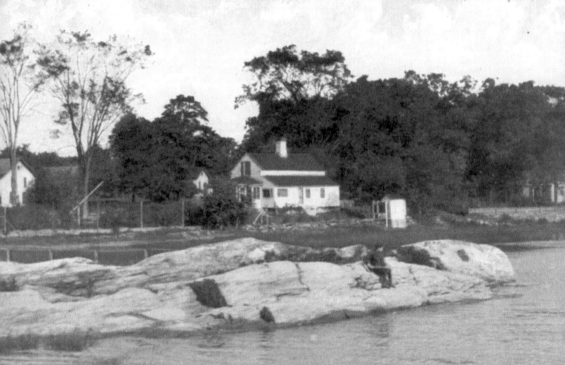

This rock, located at the mouth of Southport Harbor, was originally known as Mill River Rock. In 1795, it became known as White's Rocks after Captain Whyght, whose vessel crashed into the rocks. Fairfielders voted to give him the rocks and allowed him to make a dock on the north side, provided it did not impede or hurt the navigation of the Mill River.

Nine
SOUTHPORT POTPOURRI

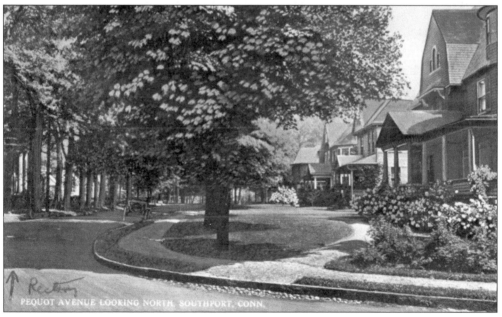

This postcard shows a view of Pequot Avenue looking north from its intersection with Westway Road. The sender of this postcard made a special point of indicating the direction to take to the Trinity Episcopal Church Rectory.

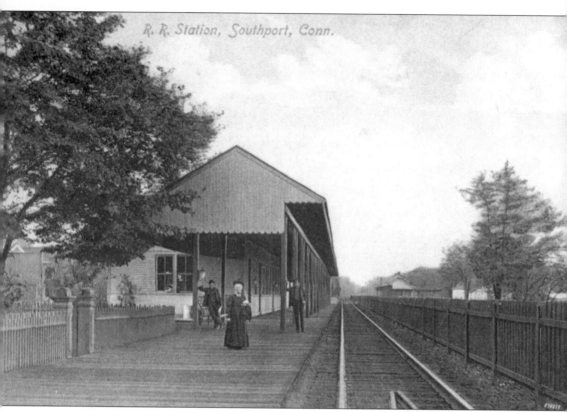

In September 1848, the New York, New Haven, and Hartford Railroad arrived in Southport. Excursions included stops in Norwalk and Bridgeport to meet steamboats bound for New York City.

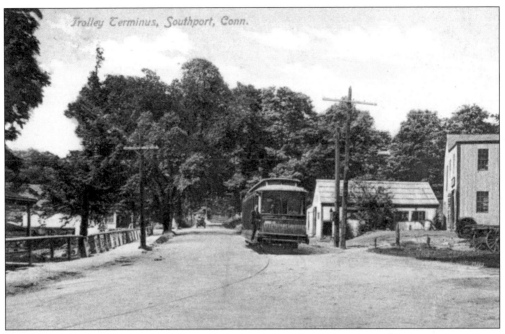

On December 9, 1894, Southport welcomed the trolley as a new means of transportation.

In this card postmarked in 1914, Denis wrote to John in Brooklyn, "You would like this place for the chippies are very nice."

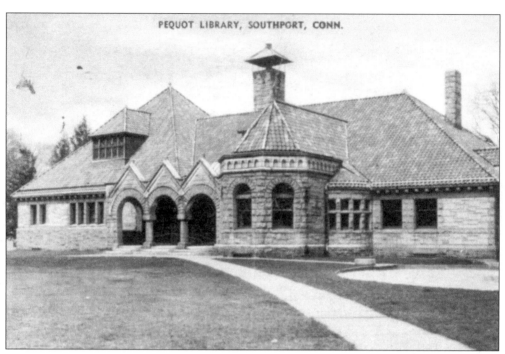

The Pequot Library, which opened in 1894, was built on the battleground of the Pequot Indian tribe.

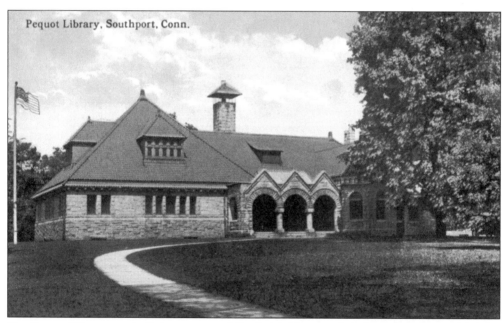

Pequot Library, Southport, Conn.

The Pequot Library was built in memory of Frederick Marquand. In his will, Marquand left his mansion and fortune to his niece Virginia Marquand Monroe "to use and distribute in the cause of education . . . and in encouraging and aiding in good works." Virginia Monroe decided that a library for the Village of Southport was to be her uncle's legacy.

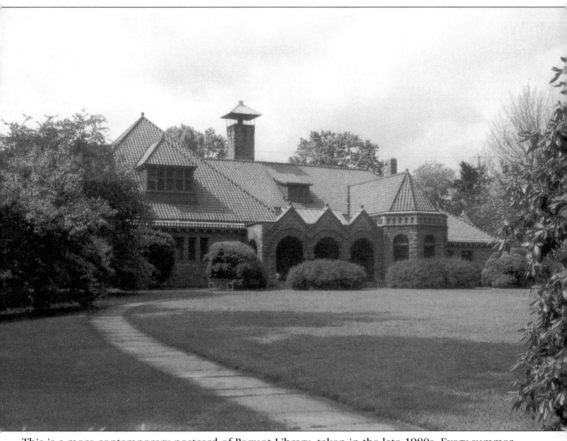

This is a more contemporary postcard of Pequot Library, taken in the late 1980s. Every summer, book lovers and collectors come from miles around to attend the annual Pequot Library book sale. (Courtesy of Ed Michaels.)

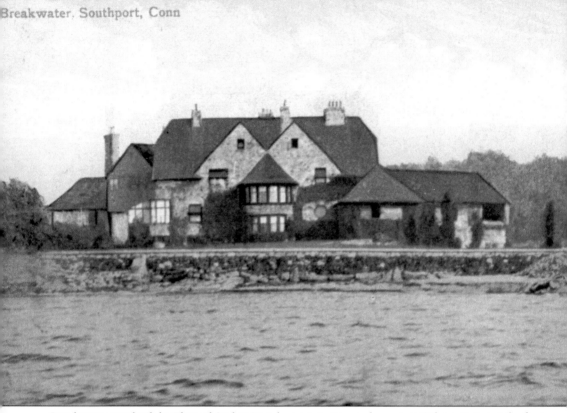

Breakwater was built by Elwood Stokes Hand on a private way known as Osborn Point at the foot of Willow Street. Construction began in 1891 and took several years to complete.

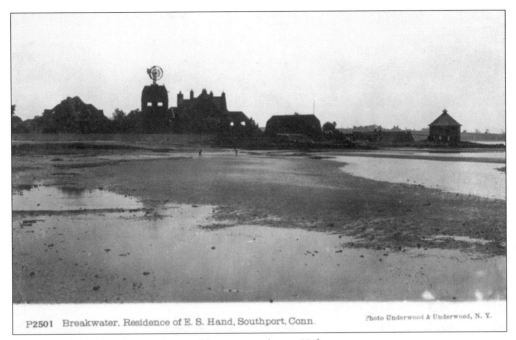

P2501 Breakwater, Residence of E. S. Hand, Southport, Conn. Photo Underwood & Underwood, N. Y.

The estate had a boathouse that could accommodate a 50-foot steamer.

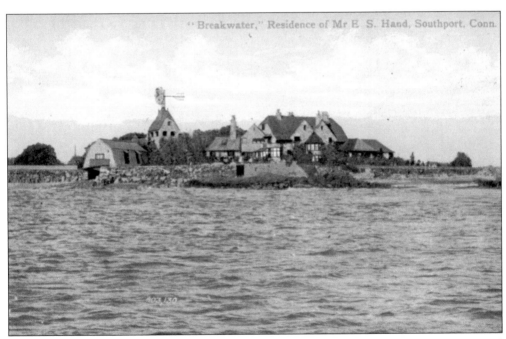

"Breakwater," Residence of Mr. E. S. Hand, Southport, Conn.

Originally containing 20 rooms, the estate had grown to 30 rooms by the time it was auctioned off and dismantled in 1939.

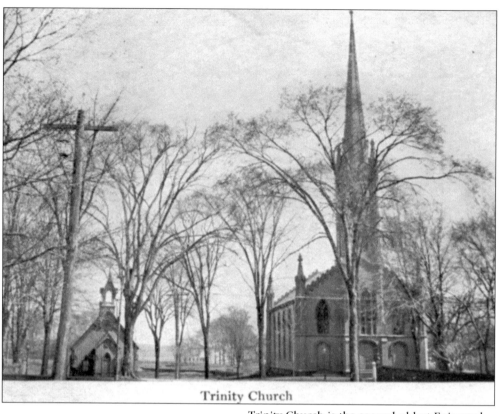
Trinity Church

Trinity Church is the second oldest Episcopal church in Connecticut. This postcard shows Trinity Church and a small chapel, which was built in 1872. In 1954, the chapel was connected to the church.

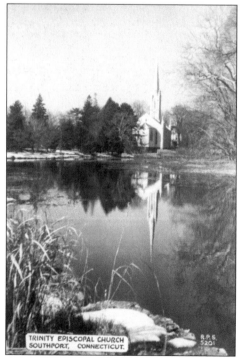
TRINITY EPISCOPAL CHURCH
SOUTHPORT, CONNECTICUT.

On May 22, 1952, Lucie wrote to Dora, "This is where I went to church this morning. Attended Dental Con. in afternoon."

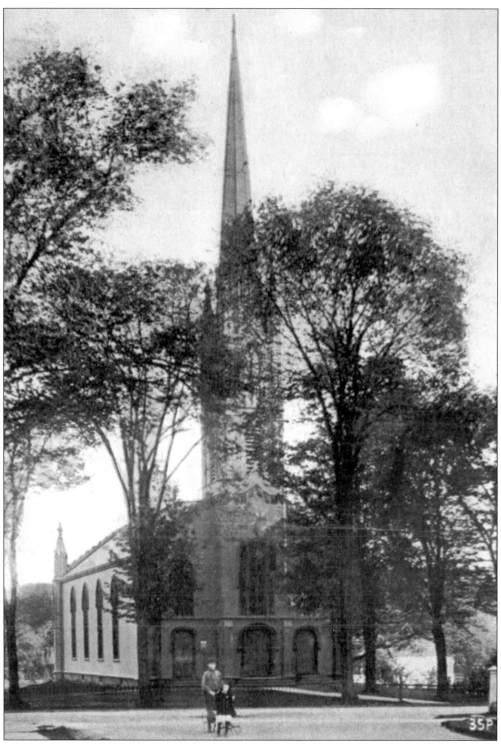

The current structure, the church's sixth, was built after the fifth structure was destroyed by a tornado in 1862.

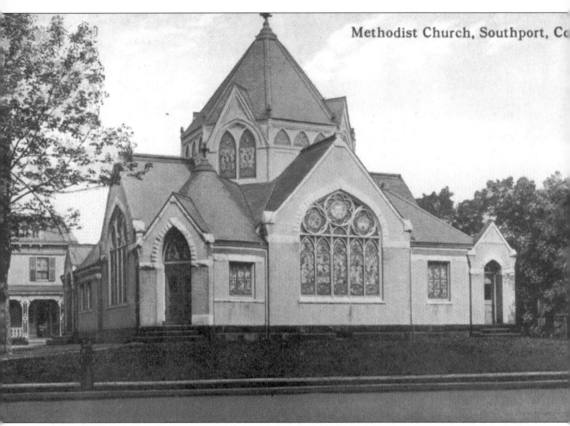

Methodist Church, Southport, Co

The Methodist church was located at the intersection of Center Street and Pequot Avenue, where the Trinity Church parking lot is today. It was torn down in the 1930s.

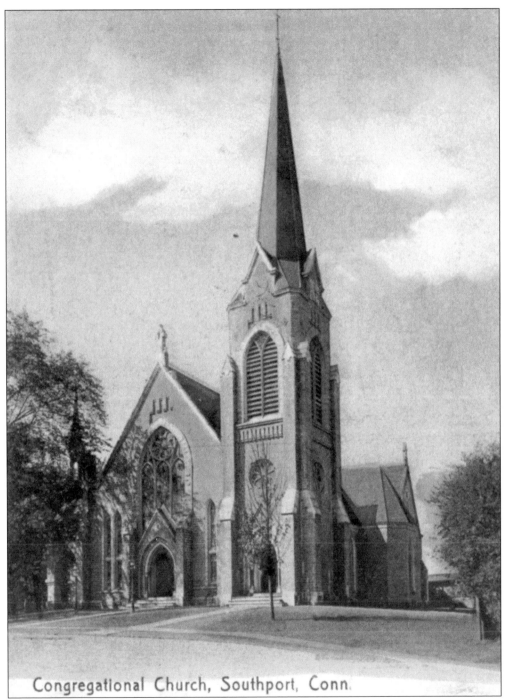

Congregational Church, Southport, Conn.

The Congregational church is located on Pequot Avenue and is the second church to occupy this site. The present church, made from stone, is 124 years old. The original church to have occupied this site was made from wood.

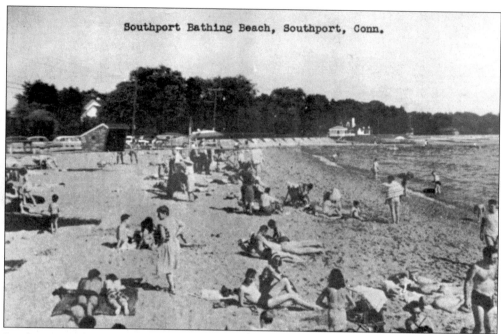

Southport Bathing Beach, Southport, Conn.

Southport Beach is the last stop on Pequot Avenue before the road becomes Beachside Avenue. Although Southport Beach is visited by many throughout the summer, it is not nearly as crowded as other town beaches due to its limited parking.

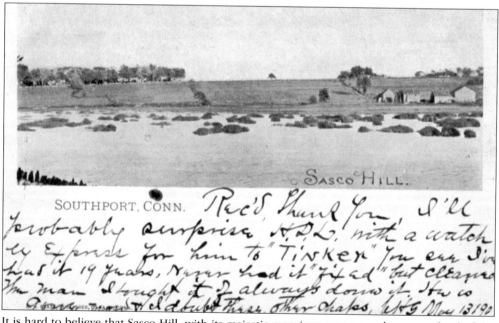

SASCO HILL.

SOUTHPORT, CONN.

It is hard to believe that Sasco Hill, with its majestic mansions, was once the pastureland of the Colonists. The area was a noted farming district and the birthplace of the famous Southport Globe Onion.

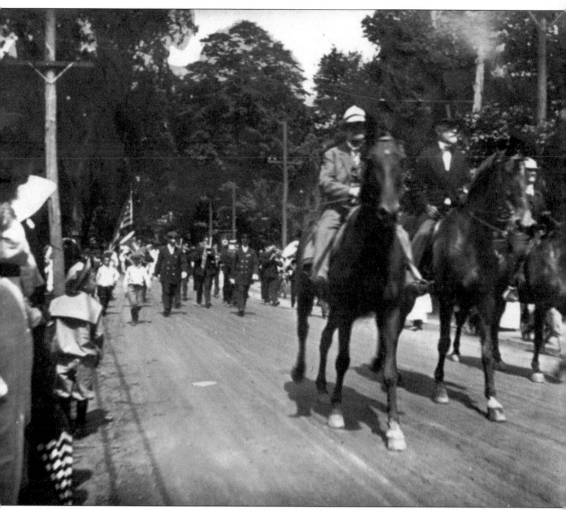

According to the reverse side of this photo postcard postmarked August 26, 1918, this is picture of the firemen's parade in Southport on August 20, 1918. The parade is led by Mr. Bulkley and Judge Perry.

Switzer's Pharmacy, on the right, moved from Southport Harbor to its current location in 1920.

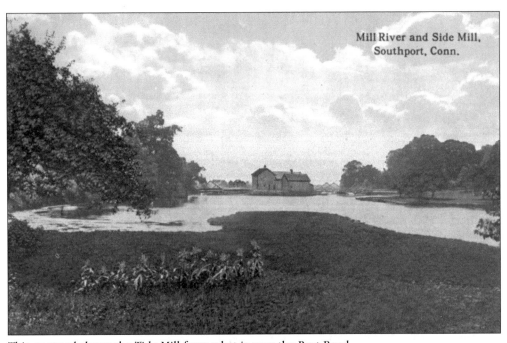

This postcard shows the Tide Mill from what is now the Post Road.

J.A. Shields was a clever business man. He advertised his hotel and "lion ointment" on the same card.

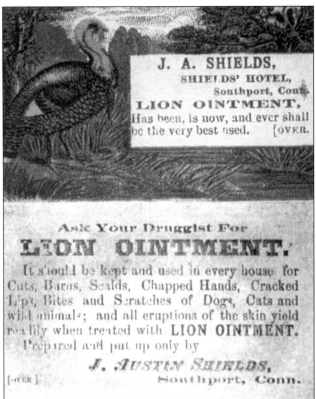

J. A. SHIELDS,
SHIELDS' HOTEL,
Southport, Conn.
LION OINTMENT.
Has been, is now, and ever shall be the very best used. [OVER.

Ask Your Druggist For
LION OINTMENT.
It should be kept and used in every house for Cuts, Burns, Scalds, Chapped Hands, Cracked Lips, Bites and Scratches of Dogs, Cats and wild animals; and all eruptions of the skin yield readily when treated with **LION OINTMENT.**
Prepared and put up only by
J. Austin Shields,
Southport, Conn.
[OVER.]

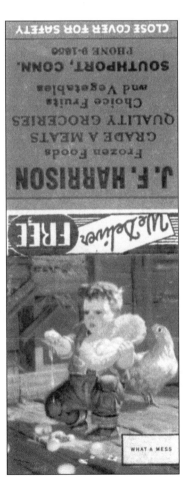

J.F. Harrison chose to advertise his store using matchbooks instead of postcards.

PEQUOT AVE., Southport, Conn.

Southport offers many examples of late-19th-century to early-20th-century gambrel-roofed style homes. The oldest example is the Mian Perry House (Nicholas H. Fingelly Real Estate building). Many other examples line Pequot Avenue, above, as well as the harbor, below.

DR. TAYLOR & C.C. CHAMBERS RESIDENCE, SOUTHPORT, CONN.

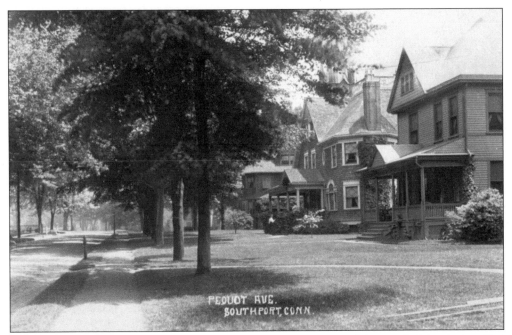

In 1895, 52 kerosene oil street lamps were mounted on posts. Of that total, 37 were installed and cared for by the Sasquanaug Association; the others were privately owned. In 1910, the Town of Fairfield provided streetlights for Southport.

According to the Master Plan for Southport, which was prepared for the neighborhood's Sasquanaug Association, "Southport has been discovered by people who appreciate the charm of the place as one of the few remaining unspoiled centers along the rapidly developing Connecticut shore."

This is Fairfield's official town seal.

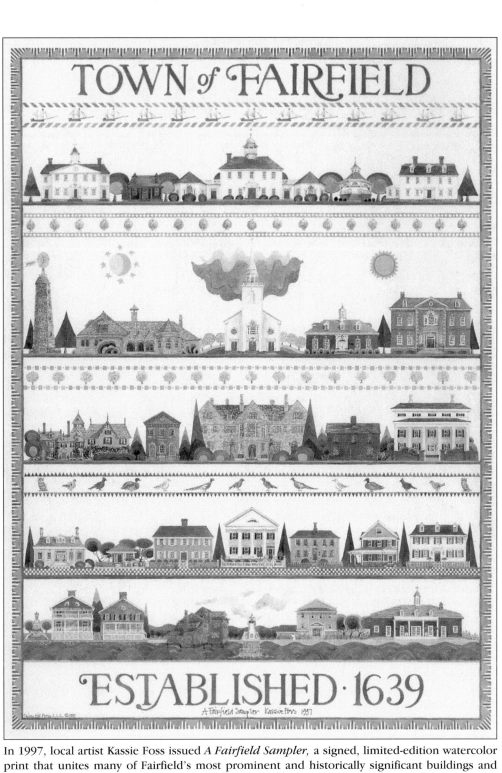

In 1997, local artist Kassie Foss issued *A Fairfield Sampler,* a signed, limited-edition watercolor print that unites many of Fairfield's most prominent and historically significant buildings and symbols. (Courtesy of Kassie Foss.)

BIBLIOGRAPHY

Austen, Barbara E., and Barbara D. Bryan. *Images of America: Fairfield*. Arcadia Publishing, 1997.

Banks, Elizabeth V.H. *About the Hill: Greenfield Hill* (A History of Its Organization), 1952.

———. *This Is Fairfield, 1639–1940*. Walker-Rackliffe Company, 1960.

Brilvitch, Charles. *Walking Through History: The Seaports of Black Rock and Southport*. Fairfield Historical Society, 1977.

Bulkley, Charlotte Malvina. *Mill River Southport: Reminiscences of the Past*. The Southport Chronicle Printers, July 1896.

A Century of Faith 1876–1976. St. Thomas Aquinas Church, Fairfield, Conn.

Child, Frank Samuel. *Fairfield: Ancient and Modern*. Fairfield, Conn., 1909.

Cigliano, Jan, and Ralph G. Schwarz. *Southport: The Architectural Legacy of a Connecticut Village*. The Southport Conservancy, 1989.

Crofut, Florence S. Marcy. *Guide to the History and Historic Sites of Connecticut*. Yale University Press, 1937.

Fairfield, Connecticut: 350 Years. Fairfield House, 1989.

Farnham, Thomas J. *Fairfield: The Biography of A Community, 1639–1989*. Phoenix Publishing for the Fairfield Historical Society, 1988.

Historic and Architectural Survey of Fairfield, Connecticut, July 1988. Fairfield Historical Society and Connecticut Historical Commission, 1988.

Lacey, Charlotte Alvord. *An Historical Story of Southport, Connecticut*. Modern Books and Crafts Inc., 1927.

Papazian, Rita. *Fairfield Neighborhoods*. Courtesy of the *Fairfield Citizen News*, copied and bound by the Pequot Library.

Pratt, George D. *Fairfield in Connecticut 1776–1976*. The Fairfield Bicentennial Commission, 1976.

The Southport Packet: The First Ten Years 1987–1996. The Southport Conservancy, April 1998.

Speer, Edward James. *Pequot: The Village School*. Edward Brothers, 1967.

Stoddard, Johnson. *Pequot Yacht Club 1921–1981*. Southport, Conn.

Ye Olde Town of Fairfield: Connecticut Tercentenary: An Historical Guide. Fairfield Publishing, 1935.